# THE HISTORY OF
# LEICESTER
## in 100 People

Stephen Butt

AMBERLEY

Medieval Leicester

First published 2013

Amberley Publishing
The Hill, Stroud
Gloucestershire, GL5 4EP

www.amberley-books.com

British Library Cataloguing in Publication Data.
A catalogue record for this book is available from the British Library.

ISBN 978 1 4456 1685 8 (print)
ISBN 978 1 4456 1698 8 (ebook)

Typeset in 9.5pt on 13pt Sabon.
Typesetting and Origination by Amberley Publishing.
Printed in the UK.

# INTRODUCTION

The title of this book prompted discussion from the outset. What criteria should be used to decide who should be included in a list of 100 individuals most influential in the development of a city?

There are men and women who have put Leicester on the national or world stage and whose names are familiar to many people. There are others who are comparatively unknown, even in the city in which they lived and worked. Some have stayed in Leicester and served the town through politics, education, business or invention. Others have travelled widely. Some lived in the area for only a short while but have made a major contribution to the city.

They have been leaders, politicians, activists, inventors, writers, thinkers and protestors. They have worked in the public spotlight, appeared in the public arena, and have studied in private behind closed doors in laboratories and libraries. For some, their presence in Leicester has been very transient, whereas others have been a powerful and dominant presence for many years.

Today, the media brings the work and activities of ordinary and not so ordinary people to the attention of the public. Some become personalities with whom we are all familiar, and some achieve that strange status of 'celebrity'. Many simply continue in the activity of their choice or persuasion and return to relative obscurity after a few moments of fame.

Advances in communication and transport, from the railways and telephones of the nineteenth century to the internet and transatlantic air flights of today, have changed the way in which inventions and ideas have become known to the wider population.

Of course, there are many individuals who have changed the course of Leicester's history who remain unknown except to their close family and friends. These are people who have influenced others by argument and example to follow a particular line of research, and they are also people who have inspired others to choose a certain career.

The further back in time we explore, the less focused our knowledge can be. With less documentation, we may have only a glimpse of the array of fascinating people. Paradoxically, the pace of change in the twenty-first century means it is impossible to foretell how some of the famous and infamous of today will be regarded by historians of the future. The children of the city today will eventually take this story further.

## AD 30–1400

1. Volisios
2. Lucius and Verecunda
3. Cuthwine
4. Ethelfleda of Mercia
5. Hugh De Grandmesnil
6. Simon De Montfort
7. John of Gaunt
8. Henry of Knighton

## 1400–1700

9. Richard III
10. William Wyggeston
11. Cardinal Thomas Wolsey
12. Hugh Latimer
13. Thomas White
14. Lady Jane Grey
15. Prince Rupert of the Rhine
16. Alderman Gabriel Newton

## 1700–1800

17. Revd William Watts
18. Mary Linwood
19. William Carey
20. Susanna Watts
21. Elizabeth Heyrick
22. William Gardiner
23. Nathaniel Corah
24. George Stephenson
25. John Ellis
26. John Flower

## 1800–1900

27. John Ella
28. Thomas Cooper
29. Thomas Cook
30. Revd David Vaughan
31. James Thompson
32. Matthew Townsend
33. Alfred Russel Wallace
34. Henry Walter Bates
35. Stephen Taylor
36. Thomas Fielding Johnson
37. Sir Israel Hart
38. Joseph Goddard
39. Wilmot Pilsbury
40. Isaac Barradale
41. Mary Royce
42. Stockdale Harrison
43. Henry Curry
44. Agnes Archer Evans
45. Sir Joseph Herbert Marshall
46. Tom Barclay
47. Henry Walker
48. Charles Bennion
49. Arthur Wakerley
50. Alice Hawkins
51. Ernest Gimson
52. Colin McCalpin
53. Harry Hardy Peach
54. Ramsay MacDonald
55. Revd James Went
56. Joseph Carey Merrick
57. George Percy Bankart
58. Benjamin John Fletcher
59. Dr Arthur Nicholas Colahan
60. Robert Fleming Rattray
61. Frederick Levi Attenborough
62. Lawrence Wright
63. Jennie Fletcher
64. Meyrick Edward Clifton James

## 1900–Present

65. Charles Percy Snow
66. William George Hoskins
67. W. Conrad Smigelski
68. James Kemsey Wilkinson
69. Francis Charles Albert Cammaerts
70. Cedric Austen Bardell Smith
71. Harold Hopkins
72. Maurice Selby Ennals
73. Elizabeth Mary Driver
74. Rt Hon. Lord Attenborough
75. Bill Woodward
76. Sir David Attenborough
77. Walter Williams
78. Baron Janner of Braunstone
79. Trevor Storer
80. Colin Henry Wilson
81. Joan Maureen 'Biddy' Baxter
82. Joe Orton
83. Arnold George Dorsey
84. Stephen Frears
85. Graham Chapman
86. Jonathan Douglas 'Jon' Lord
87. Christopher Bruce
88. Susan Lillian Townsend
89. Rosemary Conley
90. Sir Alec Jeffreys
91. John Richard Deacon
92. Dave Bartram
93. Willie Thornes
94. Gary Winston Lineker
95. Gok Wan
96. Parminder Kaur Nagra
97. Resham Singh Sandhu
98. Sir Peter Alfred Soulsby
99. Dilwar Hussain
100. Geoff Rowe

# AD 30–1400

## 1. VOLISIOS, *c.* 30–60
### Regional Leader of the Corieltauvi

Volisios is the earliest person whom we know had influence over the area in which Leicester now stands, but he is known only through inscriptions on coins. His name appears on three series of coins minted between around AD 30–60.

He was a significant leader of the Corieltauvi, the tribe that inhabited the region before and during the Roman period. These people were most likely a loose grouping of like-minded communities, each independent, but with a sense of loyalty to their neighbours. They probably shared similar social practices, and in time they recognised the leaders that inevitably grew out of these various small groups.

The coins, which have been discovered through various archaeological digs, suggest that the wider Corieltauvi peoples were initially led and possibly governed by a number of men, but, in time, one man became recognised as the most important leader. The name Volisios is often linked to coins with other leaders, including Dumnovellaunus, Dumnocoveros and Cartivellaunos.

It may be that Volisios became the leader of the Corieltauvi shortly before the Roman invasion and commissioned coinage that included the names of his three lieutenants, each being allocated a specific part of the wider territory. As the Romans advanced from the south, it is possible that he moved northwards from the Leicester area to a region where his people were able to survive for some years to come. Many coins of Volisios have been found in South Yorkshire.

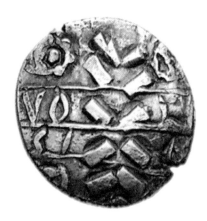

A coin from the Corieltauvi period, depicting Volisios as a significant ruler.

## 2. LUCIUS AND VERECUNDA, *c. 200*
### Roman Entertainers

Sometime in the third century, an actress, or maybe a dancer, fell in love with a gladiator. Her name was Verecunda, meaning to be shy or modest, or someone who is able to feel shame, from the verb 'to revere'. His name was Lucius.

Their feelings for each other were indicated in four words – 'Verecvnda Lvdia Lvcius Gladiator' – scratched around the rim of a broken bowl. The statement was intended to be public knowledge because the young woman turned the fragment of pottery into a necklace to wear around her neck, and the words have survived as one of the earliest written records of personal names from Leicester.

She may have found a street trader to create her amulet, or possibly the pieces of the broken bowl had a more specific significance – perhaps a reminder of a special occasion, or a love token from Lucius on the eve of a contest or following a victory. In any case, the bowl could not be discarded, so the words were etched around the rim, and a friend or street trader drilled a hole through the fragment, to enable her to add a thread and wear it with pride.

Gladiators in the Roman Empire travelled with their unique form of entertainment from town to town and country to country. Rome did employ female gladiators. It is known that women volunteered for the arena and received training. According to Petronius, writing of the earlier time of Nero, having a female gladiator as part of the spectacle was considered

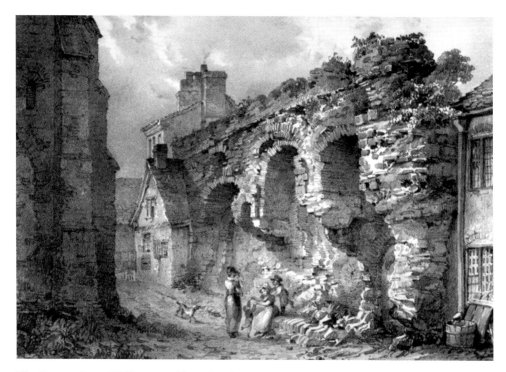

The Roman Jewry Wall engraved by John Flower.

a special treat. Possibly they performed between the main male acts as a kind of lighter entertainment, in a similar way to the role of cheerleaders in modern times. Verecunda may have been a female gladiator in her own right, possibly in the same troupe as Lucius, or she may have been a dancer or an actress, or perhaps just a young Leicester girl who fell under the spell of one of the first celebrities to visit the town. Dancers and gladiators represented roles and occupations at the opposite ends the social spectrum in the Roman Empire. The fact that her family name can be found further north in the name of a cavalry prefect on Hadrian's Wall prompts many questions such as how she reached Leicester and why.

Pots were used to transport goods as well as for storage, and Samian ware is found throughout the Roman Empire. It was made in many areas of Gaul, France and Germany, so it cannot be assumed, on the basis of the artefact alone, that Verecunda and Lucius were ever in Leicester. However, this trinket is a personal item of jewellery and its inscription indicates that it was of great sentimental value to its owner. It would seem very unlikely that this fragment travelled to Leicester separately from its owner, or that Verecunda left the town without it. Verecunda's necklace was discovered in 1854 during excavations in Bath Lane in Leicester. Fragments of a first-century glass cup, also from Leicester, have depictions of gladiatorial combat etched upon them, suggesting that such performances visited the town.

## 3. CUTHWINE, *fl.* 679 – *c.* 691
### The First Bishop of the Diocese of Leicester

Mercia was a border region between separate cultures in the north and south. The word derives from *Mierce* or *Myrce*, meaning 'border people'. Possibly, the inhabitants of Mercia shared a particular cultural disposition to living in a land between different traditions and attitudes. It is also likely that the major rivers of the region, particularly the River Trent, were used as reference points to define the extent of Mercian territory. As a border area, Mercia was where different cultural and religious beliefs were to meet and sometimes collide.

Christianity in Britain survived the withdrawal of the Roman forces in 410 and the Anglo-Saxon invasions that followed, but the remaining native Christians made no attempt to convert the pagan invaders. Against this background of a country gradually slipping back into the pagan beliefs of the past, Pope Gregory I sent St Augustine to Kent in 597 with a mission to convert the Anglo-Saxons.

In the north, St Columba had settled on Iona, off the western coast of Mull, in 563. Some seventy years later, St Aidan established the see of Lindisfarne, off the Northumbrian coast, having travelled there from Iona. This northern Celtic Christianity was based mainly around monastic establishments, whereas Augustine's mission in the south was intended to be set up on a structure of bishops and sees. The southern initiative failed when Augustine died in around 604. Soon after, the Christian convert Ethelbert of Kent also died and the area returned to earlier heathen ways.

In 653, four Celtic priests from Northumbria travelled south to reintroduce Christianity to Mercia at the request of Peada, the son of Penda, King of Mercia, who had married the daughter of the Northumbrian king Oswiu and had converted to Christianity as part of the marriage agreement.

Diuma, one of the four priests, was consecrated in around 656 as the first bishop of a new and large diocese of Mercia, which included Leicestershire, initially with the see at Repton in Derbyshire, but later in Lichfield. However, in time, it became apparent that this area was too large to manage effectively, and consequently four new smaller dioceses were created from it, namely Hereford, Worcester, Dorchester on Thames (in Oxfordshire) and Leicester.

According to Bede, the first bishop of the new diocese of Leicester was consecrated in 679; but, it may be that Cuthwine was the invention of a later writer because very little is known of him, or of the activities of the first bishop of Leicester. It is certain that the diocese was created in 679 and that from 691, Wilfrid, the Northumbrian exiled bishop of York, was in charge. It has been generally assumed for many years that the probable seat of the Saxon bishops of Leicester was on the site of the present parish church of St Nicholas. A part of the fabric of the present building dates to 880, and its prime location within (and on top of) the town's former Roman structures, near to the centre of the town where the later principal streets would cross, would suggest an appropriate location for the seat of a bishop.

After Wilfrid, the dioceses of Leicester and Lichfield were rejoined under Headda, Bishop of Lichfield, and his successor Ealdwine, who died in 737. There followed a line of seven further bishops of the see of Leicester: Torthelm, Eadberht, Unwona, Waerenberht, Hraethun, Ealdred and Ceolred. Then the Danish invasions of the ninth century made the diocese of Leicester untenable and, in 870, the see was moved to Dorchester on Thames in Oxfordshire.

In 1888, Leicester became a Suffragan diocese under Francis Thicknesse, the former Archdeacon of Northampton. The diocese was re-established in 1926 under the Right Revd Cyril Bardsley (1870–1940), who had previously served as the Bishop of Peterborough, restoring the see after an interregnum of 1,056 years. Although the old church of St Nicholas

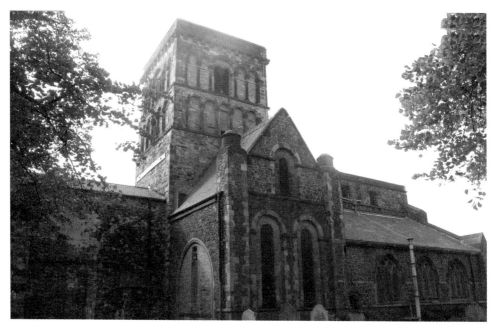

The parish church of St Nicholas, probably once the seat of the Saxon bishops of Leicester.

had recently been renovated, the nearby parish church of St Martin was instead chosen as the seat of the restored Bishops of Leicester.

## 4. ETHELFLEDA OF MERCIA, 869–918
## Mercian Military Leader

Ethelfleda was the eldest child of Alfred the Great and Ealhswith, born when the Viking invasions of the country were at their height. She married Aethelred, Lord of the Mercians, but it was after his death in 911 that she came to real prominence as a formidable military leader and strategist, capable of galvanising her scattered people to fight back.

Her tactical success was in being able to draw together forces across a very broad and fragmented area of occupied territory against the invading Danes, and to gain the support of sometimes cynical male rulers. In practical terms, she succeeded in defending her territory by setting up a series of fortified towns across Mercia, including Tamworth, where she died in 918, some months after capturing Leicester.

Her brother Edward the Elder's later success in moving against the occupying Danes in the south of England was made possible by his ability to rely on Ethelfleda during this period. It is under Edward that the Kingdoms of Mercia and Wessex were finally united.

Ethelfleda was buried with her husband at St Oswald's priory in Gloucester.

## 5. HUGH DE GRANDMESNIL, 1032–1094

The roots of the de Grandmesnil family lie in the area of Saint-Pierre-sur-Dives in Normandy. Hugh's mother, Hawisa d'Échauffour was the daughter of Giroie, Lord of Échauffour, who was reputed to have been a formidable knight. Robert, Hugh's younger brother, was for some years esquire to William, Duke of Normandy.

Hugh was banished from Normandy by Duke William in 1058 for very little cause, but was pardoned in 1063 and then given custody of the castle of Neuf-Marché-en-Lions.

In 1050, Hugh and Robert decided to found a monastery and sought the advice of their uncle, William fitz Giroie. He proposed they should restore the ancient abbey of Saint-Evroul instead, which the brothers agreed to do. In his confirmation charter to this refounding of Saint-Evroul, Duke William subscribed it with the sign of the cross and added to the charter a warning against anyone doing harm to the abbey or any of its members under pain of excommunication. That same year Robert entered the abbey as a monk and became abbot in 1059.

Hugh de Grandmesnil is one of the few proven companions of William the Conqueror who were known to have fought at the Battle of Hastings. Following the conquest, William gave Hugh 100 manors for his services, of which 65 were in Leicestershire. He was also appointed sheriff of the county of Leicester.

In 1067, he joined with William FitzOsbern and Bishop Odo in the government of England during the King's absence in Normandy. He was also one of the Norman nobles who interceded with the Conqueror in favour of William's son Robert Curthose, and effected a temporary reconciliation. William I attacked Leicester and took the town by storm in 1068. In the assault, a large portion of the town was destroyed. William handed the government of Leicester over to Grandmesnil.

In 1094, in poor health and infirm, Grandmesnil followed the example of his brother and became a monk. He died just six days later, on 22 February 1094 at Leicester. His body, preserved in salt and sewn up in the hide of an ox, was taken to Normandy by two monks, where he was buried in the abbey he had refurbished, near to his brother on the south side of the Chapter House.

Hugh de Grandmesnil first established Leicester Castle in the late 1060s at a time when the Norman hold on England was tenuous, with revolts against Norman rule in many parts of the country. Hugh's castle was positioned strategically in the south-west angle of the Roman town defences, overlooking the River Soar – a location which dominated the town, but from where the garrison could escape if they were in danger of being overwhelmed.

## 6. SIMON DE MONTFORT, 1208–1265

Immediately after Simon De Montfort's death at the battle of Evesham on 4 August 1265, even before some parts of his dismembered body had been retrieved, miracles were reported – the lame could walk again and the blind could see; even sick animals were healed. No less than forty clerics claimed that they had benefited from Simon's saintly gestures.

A decade later, however, the tales of De Montfort's saintly persona had been replaced by descriptions of his political greatness, and his death was being seen by commentators of that time as martyrdom for the liberties of the realm.

Writers in the centuries that followed continued to enhance De Montfort's reputation as a man who fought for justice and liberty. Raphael Holinshed, writing in the sixteenth century, described De Montfort as a man 'endowed with such virtue, good counsel, courteous discretion, and other amiable qualities'.

He arrived in England in 1229 to claim the title of Earl of Leicester. Little is known of his childhood, or even his date of birth, but sources do record that at around the age of ten he was with his parents at the Siege of Toulouse in 1218, where his father was killed.

His claim to the Earldom of Leicester came through his grandmother, Amicia de Beaumont, who was a daughter of the 3rd Earl of Leicester and who, with her sister Margaret, co-inherited her father's estates. Amicia and Margaret's mother, Petronilla, were descendants of Hugh de Grandmesnil.

Centuries later, it was the English Civil War that challenged historians to reopen the debate into De Montfort's legacy. Was he a rebel or a reformer? Exactly when were the seeds of parliamentary democracy sown?

Parliamentarians, unsurprisingly, argued that the main cause of the Barons' War had been Henry III's unfair taxation arising from his neglect of government. They saw De Montfort as a liberating influence, but emphasised that his principal aim was to destroy the authority of the monarchy.

After the Restoration, the argument moved towards a debate on how revolutionary the so-called De Montfort Parliament of 1265 had been. Some sought to demonstrate the concept of parliament was far more ancient and that De Montfort's actions had not involved the 'creation' of the Commons, but simply reinforced earlier rights. Others challenged the suggestion that his attitudes and personality changed with age and were tempered by experience that, in the words of Dr Clive H. Knowles, the 'self-seeking adventurer' matured into

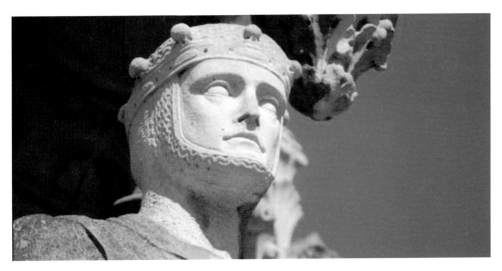

The effigy of Simon de Montfort on Leicester's Victorian clock tower.

an 'enlightened altruistic reformer'. Knowles discounts such proposals by underlying that the available evidence indicates De Montfort remained preoccupied with his own personal advancement and his total belief in the rightness of his ideas, and that his capacity for violence remained consistent throughout his life.

There is little evidence of self-sacrifice. His two sons, Henry and Simon, profited greatly from their victory at Lewes in 1264, gaining lands and wealth on a scale that seemed to suggest that the reform movement was also a campaign to enhance the holdings of the De Montfort family and its supporters.

At the heart of the baronial rebellion were De Montfort's family and his close associates, drawn from Leicestershire and the neighbouring areas. De Montfort's success was in acquiring the support and trust of a small group of powerful fighting men and a similar group of influential ecclesiastical figures, and galvanising them into a cohesive unit.

De Montfort's contribution to English constitutional development and reform was not so much a consequence of his actions, but rather in how his actions became a symbolism for later reformers. He was not the creator of responsible government and he was not the founding father of the House of Commons, but in the view of historian Sir Maurice Powicke, the man's dramatic career and masterful personality has guaranteed him a certain 'murky greatness'.

## 7. JOHN OF GAUNT, 1340–1399
### 1st Duke of Lancaster

By any standards, John of Gaunt was a man of immense wealth. His accrued riches, measured in twenty-first-century terms, amounted to a mode equivalent of more than £72 billion, indicating that he was one of the richest men ever to have lived.

His power and influence came not only from his wealth, but from his inheritance. He was the third surviving son of Edward III, and a younger brother of Edward, Prince of Wales (the Black Prince). His legitimate male heirs included Henry IV, Henry V and Henry VI.

He also fathered four children outside marriage with Katherine Swinford, his third wife, who were legitimised by royal and papal decrees after their marriage in 1396. The descendants of this marriage included Henry Beaufort, Bishop of Winchester, Joan Beaufort, Countess of Westmorland, Thomas Beaufort, 1st Duke of Exeter, and John Beaufort, 1st Earl of Somerset, the great-grandfather of King Henry VII. The three succeeding houses of English sovereigns from 1399 – the Houses of Lancaster, York and Tudor – were descended from John through Henry Bolingbroke, Joan Beaufort and John Beaufort.

Wealth, status and power worked together to create a man who engendered controversy and festering dislike among many. His ascendancy to political power coincided with widespread resentment of his influence in England, as political opinion closely associated him with the failing government of the 1370s.

Gaunt was the virtual ruler of England during the young King Richard II's minority, but made unwise decisions on taxation that culminated in the Peasants' Revolt of 1381. He was blamed for the introduction of the unpopular poll tax, and his Palace of Savoy, arguably the grandest nobleman's townhouse of medieval London, was destroyed in the rebellion.

John of Gaunt died at Leicester Castle on 3 February 1399. He was buried beside his first wife, Blanche of Lancaster, in St Paul's Cathedral. Two days later, Richard made Bolingbroke's banishment perpetual; he disinherited his cousin and seized Gaunt's vast estates for the Crown.

## 8. HENRY OF KNIGHTON, *d.* 1396
### Historian and Chronicler, Canon at Leicester Abbey

It is due to the diligence and insight of this learned canon of Leicester Abbey in the fourteenth century that we are able to understand more clearly the events of that time. Henry of Knighton lived at the abbey for more than thirty years, and was serving there in 1363 when Edward III visited. Apart from the fact that his eyesight was failing him in his later years and that as a consequence he had to suffer an incompetent copyist, little else is known about his life.

Henry was an historian and a chronicler. In his first four books he looks back in time, drawing on the work of earlier writers, to tell a history of England from the accession of Edgar in 959 to the year 1366. His fourth volume, covering the period 1337 to 1366, is a contemporary chronicle written by Knighton himself. A fifth book, covering the period 1377 to 1395, was for some years regarded as the work of another historian, possibly a fellow canon, but it is now accepted as Knighton's work, and was written before the other books.

It is clear from the richness of his writing that Knighton was a man of considerable insight, who was not only aware of the political landscape of England and Europe, but could interpret the events as they took place. He understood the motivations that lay behind rebellion, such as the Peasant's Revolt. While not supporting the cause, he recognised the causes of the revolt. He condemned the actions of the rebels, but unlike other commentators, did not refer to them in derogatory terms, and was able to set out the background to the events that took place.

Similarly, Knighton provides an insight into the activities of John Wycliffe and his followers, respecting Wycliffe as an academic, but distancing himself from his theology.

Knighton was a contemporary of John Wycliffe and was a student at Oxford when Wycliffe was a master there. Wycliffe was rector of Lutterworth from 1374 to 1384. Knighton paints a vivid picture of Wycliffe, and while he was horrified at the rise of lollardy, the first indications of protestant dissent in England, he respected Wycliffe as an academic.

Although the Abbey of St Mary de Pratis, as its name suggests, was located in land several miles east of the town of Leicester, distant from the town walls and on the opposite bank of the River Soar, Henry Knighton's works indicate that it was very well connected with the secular world of economics, politics and business. More than 100 political and ecclesiastical documents of national relevance are quoted by Knighton, and it is obvious that he was close to sources of news from far afield.

The abbey's benefactors and supporters during Knighton's time were Henry of Grosmont (*c.* 1310–61) the 4th Earl and 1st Duke of Lancaster, and his son-in-law and successor John of Gaunt (1340–99). Both men feature prominently in Knighton's narrative. These were men of great power and influence in England and abroad, but the Chronicle does not simply celebrate their activities. Knighton observes and understands the political context in which John of Gaunt and others acted.

The Chronicles provide a fascinating insight into the human effects of events. In recounting the arrival of the Plague in Leicester (1358–1359), Knighton is able to link the personal tragedies of this event with the economic effects on prices, wages and taxation. He writes:

> And there died at Leicester in the small parish of St. Leonard more than 380 persons, in the parish of Holy Cross, 400; in the parish of St. Margaret's, Leicester, 700; and so in every parish, a great multitude.
>
> After the pestilence, many buildings, great and small, fell into ruins in every city for lack of inhabitants, likewise many villages and hamlets became desolate, not a house being left in them, all having died who dwelt there; and it was probable that many such villages would never be inhabited. In the winter following there was such a want of servants in work of all kinds, that one would scarcely believe that in times past there had been such a lack. And so all necessities became so much dearer.

Henry of Knighton's works were kept in the library of the abbey in which he served, along with more than 900 other volumes. A catalogue of the library survives. Possibly, his role as a canon included the safekeeping of the abbey's records. His principal text, of which a part may be in Knighton's own hand, is now part of the Cottonian collection in the British Library (*BL Cotton Tiberius C vii*). A copy made some decades later, probably in Leicester, is also in the British Library (*BL Cotton Claudius E iii*).

A page from Knighton's Chronicle.

# 1400–1700

9. RICHARD III, 1452–1485
King of England, 1483–1485

Until the summer of 2012, a smokescreen of myth and legend surrounded the accounts of the treatment and disposal of the body of Richard III after his defeat at Bosworth Field on 22 August 1485.

It was generally agreed that Richard's body had been lain on public view in the church of the Annunciation of St Mary in the Newarke for several days before being handed over to the Greyfriars, who hastily buried him within their precincts. Later, accounts tell of his body being dug up and thrown into the nearby River Soar, and following the Dissolution, the location of his tomb was lost or forgotten.

For many years, members of the Richard III Society visited Leicester and followed the probable route of the King's body over the site of the old West Bridge, into the Newarke, and then through the south gate of the town to the precincts of the Greyfriars. In the form of a pilgrimage they visited more than one car park, located east and west of New Street, constructed in 1740, which cuts through the former friary land.

On the edge of the western car park, on the boundary of the properties fronting Peacock Lane, the Ricardian Pilgrims would stop and observe an old and much-defaced wall, known to have dated in part to the later period of the Greyfriars. A solicitor in New Street – where many legal firms have their offices – would tell them that he believed the late King was buried beneath the large tree that stood behind his chambers.

Later, the pilgrims would gather in the shadow of the grand but empty bank on the corner of St Martin's and Hotel Street, to view the plaque that proposed the King was buried nearby. The true resting place of the dead King was indeed close by.

The original owner of the bank and a considerable portion of the former Greyfriars land was Thomas Pares, a local banker, who died in 1824. The land and buildings, including the Mansion House, built nearby, were sold to Beaumont Burnaby and by 1863, the mansion house had been divided, occupied in part by Burnaby's widow and also by a Mrs Parsons.

In that year, Mrs Parsons sold part of the land to Alderman Newton's Boys' School to enable a new building to be constructed to replace their outdated and dilapidated premises in Holy Bones nearby. The school was built in 1864, and extended in 1887 and 1897.

It was in the shadows of this building, close to the perimeter wall of the playground, where the skeleton of Richard was found during the archaeological excavations of the University of Leicester's Archaeological Services in August 2012.

For the worldwide membership of the Richard III Society, an unquestionably 'glorious summer' was followed by a period of anxiety as the skeleton was subjected to much scrutiny and scientific analysis, and a 'winter of discontent' as the city of York sought to claim Richard as their 'son of York'.

The discovery of Richard III's remains resulted in an uneasy alliance of differing interests. Alongside the precise, scientific analysis and processes of the archaeologists and academics are the emotional outpourings of the Ricardians, for whom the events of 2012 have significance almost beyond measure. An even stronger influence on future events is the tourism and commercial aspirations of Leicester City Council, which owns the land where Richard was found. The council provided part of the funding for the dig. Close by are the Dean and Chapter of Leicester Cathedral, keen to offer the late King the respect and final rites to which all are entitled, but knowing also that the presence of his remains inside their church will mean a secure financial future for their work. It is a scenario worthy of the bard of Stratford.

## 10. WILLIAM WYGGESTON, *c.* 1467–1536
### Wool Merchant and Benefactor

In 2013, the Wyggeston Hospital in Leicester celebrated its quincentenary, commemorating its founder and also celebrating its continued well-being as a caring institution for the twenty-first century, proud of its long history. Unlike many charitable enterprises of the past, the Wyggeston Hospital is one that continues to thrive, due to its good and efficient management, and to the sound financial footing on which it was founded.

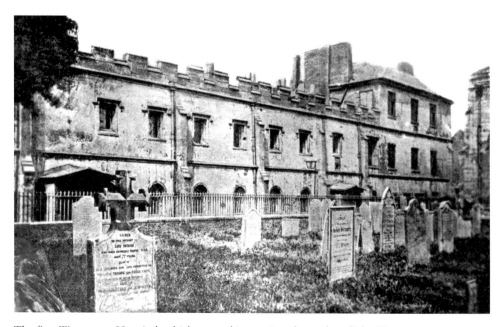

The first Wyggeston Hospital, which opened in 1518 and was demolished in 1874.

The sound management of finance appears to have been a natural talent of the Wyggeston family. The family had been influential in Leicester for several generations, and although some aspects of William's ancestry have yet to be confirmed, it is certain that his father, John, served as mayor of Leicester on three occasions, and was also mayor of Coventry, mayor of the Staple of Calais, and MP for the borough. William's grandfather, also named William, was the mayor of Leicester on two occasions, and MP for the borough.

The wealth and authority William inherited does give much credence to the likelihood that he would have witnessed the dramatic events of August 1485, before and after the Battle of Bosworth. A young man of eighteen, he was living in Highcross Street near the Blue Boar Inn, where Richard stayed on the eve of the battle. The son, grandson and nephew of mayors of Leicester, William was later admitted as a freeman of the borough, and mayor of Leicester.

William founded his hospital in 1513. It was completed in 1518. In his own words:

> Upon a certain piece of ground of mine within the city of Leicester, near the churchyard of the parish of S. Martin, on the west and within the bounds of the said parish, I have built, erected and founded a certain hospital forever.

Why did William Wyggeston decide to commence his programme of benevolent 'good works'? He was undoubtedly concerned about saving his soul for eternity, and there is a distinct sense in the documents that have survived of a man believing that he had reached a point in his life when he needed to take stock and consider whether that life had been led with the necessary piety. Yet when he revealed his great hospital project, he was only forty-five years of age. He had no children, and it seems very likely that he would have wanted to pass on his wealth and status to a further generation. Lacking that opportunity, William instead made sure that others were able to benefit from his wealth over many centuries.

## 11. CARDINAL THOMAS WOLSEY, *c.* 1475–1530

One of the many who died on Bosworth Field in 1485 was Robert Wolsey of Ipswich. It was his son who climbed the ladder of political influence under Henry VII, reaching the very highest levels of secular and religious power in the land under Henry VIII, before later suffering a devastating fall from grace.

Thomas was buried in the county of Leicester, but less than ten years after his body had been laid to rest in Leicester Abbey, its precise location had been all but forgotten.

Wolsey entered the church after his education at Magdalen College, Oxford. In 1507, he entered the service of Henry VII. It was the formidable combination of his remarkable intelligence, his ability to organise, his willingness to push himself hard, and his driving ambition that enabled his rise to great power; but he was also a man who could achieve a rapport with those whom he needed to influence, including Henry VII.

Wolsey was to wield more power than possibly any other servant of the Crown in English history, but although Henry VIII gave him an immense amount of freedom in managing domestic affairs, it took only one failure to end his career.

Wolsey's failure to secure the annulment of Henry's marriage to Catherine of Aragon was the cause of his fall from grace. Those who supported Anne Boleyn persuaded the King that

Wolsey was deliberately dragging his heels. Wolsey was arrested and relieved of his powers, duties and property.

He was, however, allowed to remain as Archbishop of York, and travelled to that city for the first time in his life. He was later ordered by Henry to return to London after being accused of treason. It was on this journey that Wolsey fell ill and sought refuge in Leicester. He died in the town on 29 November 1530 and was interred at Leicester Abbey.

Although the site of the abbey has been scrutinised by historians, the location of Wolsey's tomb is not known. The only apparent commemoration of this remarkable if controversial man is a statue, which has stood in the grounds of the Abbey Park café since 1979. It was originally commissioned by Wolsey Knitwear, and was first located at their premises in King Street and at Abbey Meadows. It is now known that the statue is the work of sculptor Joseph Morcom, who taught at the Leicester College of Art, and whose workshop and yard were located behind Trinity Hospital in the Newarke.

## 12. HUGH LATIMER, c. 1487–1555
Protestant Reformer

Number 27 Anstey Lane, Thurcaston, is an address in current street directories that seems a rather mundane-sounding location for the birthplace of one of England's most respected voices of the English Reformation.

On more than one occasion, the paths of Cardinal Thomas Wolsey and Leicestershire's protestant theologian Hugh Latimer crossed. At those meetings and at that time, the shrewd Wolsey judged Latimer's activities to be of little consequence to the realm and allowed him, after mild reprimands, to continue his preaching.

Throughout Leicester's long history there has been a record of its association with, and often support for, those with dissident beliefs. John Wycliffe came under the protection of John of Gaunt during his later years as Rector of Lutterworth (1374–84). Later dissident voices in Leicestershire were to include George Fox of Fenny Drayton who founded the Quakers (1624–91), Philip Doddridge and others at the Dissenting Academy in Kibworth Beauchamp in the eighteenth century, and the Baptist missionary and bible translator William Carey. These men of faith all survived to live out their beliefs, though sometimes in controversial and difficult circumstances, but Hugh Latimer paid for his religious convictions with his life.

Latimer was born into a farming family in Thurcaston, north of Leicester, in around 1487. He was the only boy, although he had six sisters. His father was a reputable yeoman, and Latimer would later recount the facts of his modest background and the honest toil of his father who kept 100 sheep and 30 cows, was able to give his daughters five pounds each on their marriages, was always willing to give to the poor, and who lived hospitably among his neighbours.

Latimer was educated locally and then in nearby Leicester before attending Christ's College, Cambridge, at the age of fourteen, where he was acknowledged as a fine student. He obtained a fellowship at Clare College and became a Master of Arts, before deciding to become ordained. Although the ideas of the reformers on the continent had already reached England, they were not at that time seen as a threat to the establishment, and in his first

years as a priest, Latimer continued to support and defend the Pope's authority, and to oppose vigorously the English Reformation movement as it began to take hold.

Latimer's personal views changed dramatically after a meeting with his friend Thomas Bilney, a leader of the reformers in Cambridge. Bilney respected his friend's honesty and sincerity, and believed that he could persuade Latimer to change his views. He trusted his friend to hear his own confession of conversion to the reformers, and Latimer was convinced. Within a relatively short time, he was to become one of the leading spokesmen of the Reformation, his sermons being powerfully challenging and influential because of their simplicity.

Inevitably, his uncompromising beliefs attracted intense persecution and he was banned from preaching in the university and diocese of Cambridge. Charges of heresy were brought against him and he was called before Thomas Wolsey on several occasions. Wolsey felt that the allegations were trivial and driven by personal dislike for a charismatic preacher, and dismissed them, giving Latimer the authority to preach anywhere in the country.

In defending Henry VIII's divorce from his first wife, Catherine of Aragon, Latimer's reputation grew. He was made Bishop of Worcester and became a close advisor to the King, but his strong Protestant beliefs led to him refusing to accept the King's 'Six Articles' in 1539, which were intended to stop the spread of Reformation doctrines. Latimer resigned as bishop, and lived for the rest of Henry VIII's rule in confinement in the bishop's palace in Chichester.

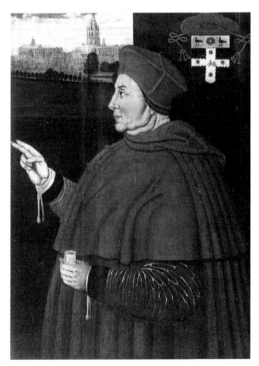

Cardinal Thomas Wolsey.

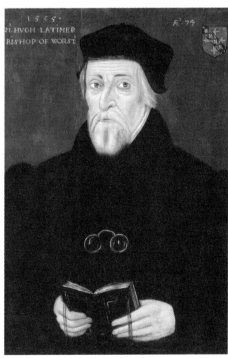

Hugh Latimer *c.* 1487–1555.

He regained favour and support when Edward VI came to the throne in 1547 and resumed his preaching, residing with his friend Thomas Cranmer, and playing a major role in the Reformation. But on the accession of Mary Tudor in 1553, Latimer, along with Cranmer and Nicholas Ridley, was arrested, tried for heresy and imprisoned in the Tower of London. He and Ridley were burned at the stake in Oxford on 16 October 1555.

## 13. THOMAS WHITE, 1492–1567
### Cloth Merchant, Benefactor and Founder, St John's College, Oxford

Thomas White never lived in Leicester, and he probably never visited the town. Yet his benevolence has fostered the birth and growth of thousands of businesses throughout Leicester, Leicestershire and Rutland. His image stands with those of Simon de Montfort, William Wyggeston and Alderman Newton around Leicester's clock tower.

In the mid-sixteenth century, White created a charity to support young men who were planning to launch themselves into the world of business and commerce. It was a path that he himself had trod with great success. As an ambitious young man, White was managing his own business before the age of thirty, and rose so rapidly that in 1546, he was made lord mayor of London. He was also the founder of St John's College, Oxford.

He was a man of incredible generosity; he gave away all his riches. Although he lived comfortably, he had virtually nothing at the time of his death. An indication of the wealth amassed by Sir Thomas and his many charitable enterprises is the value of his foundations in 2012. Since its inception, his Leicester charity has received income from properties in Coventry and, at the close of the 2012 financial year, the charity's reserves were in excess of £3.5 million. In an age of economic austerity, the charity is still enabling fledgling businesses to take root, providing interest-free loans, and creating enterprise in the heart of the modern city at a time of recession.

White was born in Reading, Berkshire, and was brought up in London. He served as sheriff of London in 1547, and was elected lord mayor of London in 1553. He was knighted in the same year by Mary I. He was a member of the commission for the trial of Lady Jane Grey.

In 1553, he helped to open trade across Russia with the object of finding a route to China. Three ships were sent to north Russia, but only one survived the bitter weather to reach Archangel. The English merchants succeeded in attracting trade with Russia through the Baltic, and drew great wealth from the furs and hemp they bought and sold.

For many years, loans were limited to £100, which prompted the charity's nickname of the 'Town Hundred'. Currently, the charity offers interest-free loans of up to £15,000, which must be repaid within 9 years.

## 14. LADY JANE GREY, 1536/37–1554

For centuries, Lady Jane Grey has been presented by writers and historians as the innocent teenage girl from Leicester who was the de facto Queen of England for nine days, and was sacrificed at the altar of her mother's conniving ambition. Her mother, the eldest daughter of Henry VIII's sister, has been described as having many of the king's physical and behavioural traits, including a penchant for domineering and bullying her daughters.

Recent research is questioning this interpretation of the facts about Jane's short life. One very basic question concerns the traditional view that she was born in Leicester on her family's estate of Bradgate Park in 1537. Historian Eric Ives, in his biography published in 2009, presents research that suggests Jane was born in London, some years earlier. However, it is still a story of drama, intrigue, corruption and scheming.

The Grey family acquired Bradgate Park from the Ferrers family through the marriage of the only surviving daughter of the Ferrers dynasty to Edward Grey in 1445. The Greys held the estate for over 500 years until 1928, when it was purchased by a local businessman, Charles Bennion, who gifted it to the people of Leicestershire.

Jane's mother, Lady Frances Grey, Duchess of Suffolk, was a familiar and active figure in the court of Henry VIII, and enjoyed a particular friendship with the King's sixth wife, Catherine Parr, who was a wardship for her daughter. It was then inevitable that the young Jane would come into contact with Edward, Henry VIII's son, who was just nine years old when he succeeded to the throne in 1547.

When Catherine Parr remarried (to Thomas Seymour), Jane accompanied her to her new home. Jane's parents began scheming with Seymour to arrange a marriage between her and the young King. Catherine Parr died in 1548, and Jane moved into her quarters despite attempts by her parents to remove her from Seymour, whom they felt could not be trusted with the young girl. Seymour continued to pressure the King into marriage, but Edward's growing distrust of his uncle led to Seymour's execution for treason in 1549.

Jane's parents altered their strategy. They were successful in convincing the Privy Council that they had played no part in Seymour's scheming, and then sought an association with the new lord protector, John Dudley, 1st Duke of Northumberland, arranging the marriage of Jane to his son Lord Guildford Dudley. Although the interpretations of events vary, it is certain the young girl was forced by her parents into this marriage, which took place on 15 May 1553.

Less than eight weeks later, Jane was declared Queen of England. Her succession was due to the dying Edward VI's concern that the Protestant Reformation would die with him if his half-sister Mary succeeded him. Northumberland arranged for the King's will to exclude both Mary and Elizabeth from the succession on the grounds that they were illegitimate, Henry VIII having had his marriages to their mothers annulled. Jane's mother was third in line to the throne, but Edward was persuaded by Northumberland to pass her over in favour of her eldest daughter.

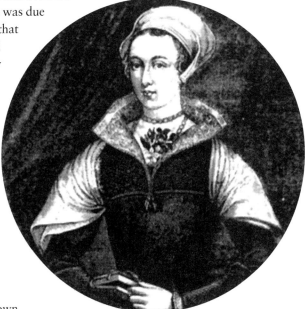

*Lady Jane Grey.* The artist is unknown.

Northumberland's success in preparing the way for his male heirs to become the kings of England was short-lived. Nine days later, Jane was deposed in favour of Mary, whose retaliation was swift and brutal. Jane and her husband were arrested and charged with high treason. A trial by special commission was arranged, presided over by Thomas White, the man who was later to be known as one of Leicester's most generous benefactors. With two of Dudley's brothers, all were found guilty.

Initially, it was thought that Jane's life might be spared, but the Protestant Rebellion of January 1554, led by Thomas Wyatt, sealed her fate, even though she played no part in it. She was executed at Tower Hill on 12 February 1554.

## 15. PRINCE RUPERT OF THE RHINE, 1619–1682

The people of Leicester suffered badly during the storming of the town on 31 May 1645 by Royalist troops led by Prince Rupert of the Rhine. The town was vulnerable to attack, with minimal physical defences and lacking military leadership.

Leicester was a town in both the right and the wrong place. In 1645, when King Charles I was losing heavily to the Parliamentarian forces, his army, led by Prince Rupert, moved northwards with the intention of regaining control of the north of England. News was received of an attack by the Parliamentarian New Model Army on Oxford, a Royalist stronghold that the King needed to retain. The march to the north was halted, and Prince Rupert decided that an attack on Leicester would lure the Parliamentarians away from Oxford. Leicester was also strategically useful as a base in the heart of the country between other Royalist-held towns such as Newarke and Ashby.

Prince Rupert was a nephew of Charles I. His mother, Elizabeth, was the daughter of James I. He was a man of remarkable talents, being an amateur artist, scientist and sportsman, as well as a naval admiral, colonial governor and military man. He was an experienced soldier from an early age, and was already a veteran of several major conflicts by the time he became commander of the Royalist army when he was just twenty-three years of age.

He has had a reputation for being brutal with his enemies, allowing his men to kill and plunder apparently without restraint, but recent histories have exonerated him to some extent.

Two days before the attack on Leicester, forces led by Sir Marmaduke Langdale surrounded the town, cutting off the approach routes. A battery was set up on the Raw Dykes, and Prince Rupert issued a summons to surrender at midday on 30 May. Sometime later, a messenger was sent to Sir Rupert from the town's committee asking for more time. Prince Rupert responded by beginning a major bombardment, concentrating on a section of the wall that formed the boundary of the Newarke.

By evening, the wall had been breached. Troops led by George Lisle stormed through the breach, supported by two other attacks by soldiers, with ladders targeting the north and east gates. The town resisted for some time but, ultimately, the defenders were overcome, the gates were opened and the main Royalist cavalry entered.

Those who defended Leicester fought until the last possible moment. The fighting continued, even after the gates had been breached, with battles in each street until the remnants were cornered in the market square and finally threw down their weapons.

Prince Rupert, exasperated by the resistance, made no attempt to rein in his troops who then sacked the town, displaying considerable brutality. Overall, some 300 defenders were killed in the fighting, but the Royalists lost around 400 men.

After capturing Leicester, the Royalist army marched towards Oxford. But with the Parliamentary forces camped at Naseby in Northamptonshire, on 5 June 1645, Prince Rupert's troops plundered Market Harborough, where Charles I then set up his headquarters. One week later, the battle of Naseby took place. It was a decisive victory for Oliver Cromwell, who led his troops into battle. The victorious Parliamentarians pursued the King's forces in retreat back through the town, detaining Royalist prisoners in the church, while those who escaped hid in the countryside.

Rupert's career was as long as it was controversial. He died on 29 November 1682 of pleurisy. He was given a state funeral and was buried in the crypt of Westminster Abbey.

## 16. ALDERMAN GABRIEL NEWTON, 1683–1762

Popular brief biographies of Gabriel Newton describe him as a man who rose to prominence and became one of Leicester's principal benefactors from comparatively lowly circumstances. He is usually presented as the eldest son of a wool comber from a family that had lived in the village of Houghton-on-the-Hill for several centuries, who became the landlord of the Horse & Trumpet Inn, near to Leicester's High Cross, and who, some years later, served as the mayor of the town. He is commemorated with a statue on Leicester's clock tower.

The most detailed biography of Newton was written by Professor R. W. Greaves in 1938 in the *Transactions of the Leicestershire Archaeological and Historical Society*. Greaves explains that Newton's philanthropy and interest in education stemmed from his family. His father, Joseph Newton, left Leicester in 1684 to take charge of a school in Lincoln, which educated 'the poor in knitting and spinning'. Joseph, who was indeed a 'jersey comber' by trade, died in Lincoln in 1688 when Gabriel was just five years old.

Possibly, Gabriel was cared for by his great-uncle John Newton. John was made vicar of St Margaret's in Leicester in 1663 and of St Martin's in 1680, at which time he also served as master of Wyggeston's Hospital. Gabriel began his working life as an apprentice in the wool trade, the same trade which had provided the Wyggeston family with the means to create their schools and hospital. He later turned to the victualling trade as the innkeeper of the Horse & Trumpet, almost in the shadow of St Martin's. As a tradesman and the eldest freeborn son of his father, he had the right to seek the freedom of the borough of Leicester, which was awarded to him in 1702. He then had the right to 'ply his trade' within the town. More importantly, the office of freeman gave him access to the civic hierarchy, and led him to become mayor of Leicester in 1732.

Those intervening years were occupied in various civic duties. From 1709 he undertook the rather thankless, arduous and sometimes dangerous task of constable of the ward in which he lived. It was an unpaid post that entailed reporting on the criminal activities of his neighbours. In 1710, he became a member of the company of forty-eight common councilmen and in 1711, was a collector for the poor, as well as serving as a churchwarden at both St Mary de Castro and St Martin's.

From these relatively lowly offices he graduated quickly to more responsible positions within the town. He served the corporation as chamberlain in 1720 and became an alderman in 1726. Finally, in 1732 he reached the summit of his civic progress by becoming the mayor.

Gabriel Newton's membership of the Corporation of Leicester occurred at a time of great turmoil and change. It was a period of much political strife locally, with the wider backdrop of the Jacobite scares. And, somewhat remarkably, he was interested in the development of road traffic (perhaps because of his former occupation of innkeeper). He represented Leicester on the trust of the Leicester to Harborough turnpike, to which the town gave a loan.

However, of greater significance is the fact that as an alderman, Gabriel Newton had an oversight of education in the town, a role for which his family background provided practical qualifications. It is said that he was involved in the management of the grammar school close to his inn on Highcross Street.

He was married three times, to Elizabeth Wells in 1715, Mary Bent in 1728, and Eleanor Bakewell in 1738. Each marriage consolidated his standing within the leadership of the borough and added considerably to his wealth. His only child to survive beyond infancy was named after his father, but he died in 1746 at the age of eighteen years. Gabriel Newton died on 29 October 1762, aged seventy-eight. He was buried in All Saints' churchyard.

There is no known likeness of him; the statue on Leicester's clock tower is an imagined likeness. There is a mural tablet to his memory in the chancel of All Saints' church, and the inscription is repeated on the altar tomb which marks his grave in the churchyard. Busts of his two first wives and youthful son remain in the chancel of St Martin's.

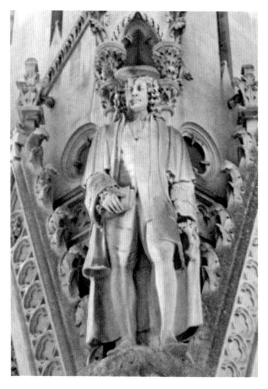

Gabriel Newton: the effigy on Leicester's Clock Tower.

# 1700–1800

## 17. REVD WILLIAM WATTS, 1725–86
### Founder, Leicester Royal Infirmary

Although described in some accounts as a doctor from Northamptonshire, William was a descendant of a Leicester family. In 1700, John Watts had acquired Danet's Hall and built a new house on the site near to the modern junction of Fosse Road and King Richard's Road.

After gaining his medical qualification in 1757 from King's College, Aberdeen, Watts became an honorary physician to the newly opened County Infirmary in Northampton. This pioneering hospital had been founded by the Revd Philip Doddridge of the Kibworth Dissenting Academy, and the Revd John Stonhouse, who was also a physician. Believing that Leicester needed a similar establishment, and impressed by Stonhouse's work at Northampton, Watts resigned his post in 1762, took holy orders, perhaps following the example set by Stonhouse, and became the curate-in-charge of St Giles' parish church in Medbourne in Leicestershire.

At Medbourne, Watts began a campaign to raise funds for a hospital in Leicester. As at least three of the vicars of Medbourne during his incumbency were not resident, it is likely that he was free to devote his efforts and time to this cause. He used his powers of persuasion, citing the success of the Northampton Infirmary as an example of what could be achieved, writing many letters of appeal in the *Leicester Journal*, and setting up a subscription fund. In 1768, land in Leicester was acquired, plans by the architect Benjamin Wyatt of Staffordshire were approved, and building commenced. The infirmary, providing accommodation for forty beds, opened three years later. Watts continued his work by moving into the nearby Danet's Hall. An asylum for lunatics was added to the hospital in 1782, and numerous other wings and buildings were added. The infirmary gained its 'Royal' status in 1912. In the 1940s, the Friends of Leicester Infirmary donated a new east transept window to Medbourne parish church to commemorate Watt's work and achievements. He was an uncle of Susanna Watts, the reformer and human rights activist, who was also the author of Leicester's first guide book, published in 1804. In this, Miss Watts describes her uncle's creation, but adds very little about its founder:

> At the end of this (horsepool) street, situated on a gentle eminence affording the desirable advantages of a dry soil and open air, we perceive one of those edifices which a country more than nominally christian must ever be careful to erect, a house of refuge for sick poverty. The Infirmary, which owes the origin of its institution to W. Watts, M. D. was built in 1771, nearly on the scite of the antient chapel of St. Sepulchre, and is a plain neat building with two wings, fronted by a garden, the entrance to which is ornamented with a very handsome iron gate.

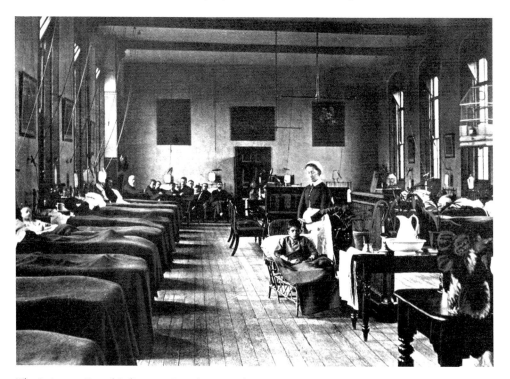

The Leicester Royal Infirmary: St Luke's Ward in 1890.

The Leicester Royal Infirmary: An engraving from *c.* 1850.

## 18. MARY LINWOOD, 1755–1845
## Embroiderer and Patron of the Arts

Mary Linwood was born in Birmingham and moved to Leicester as a child when her mother opened a boarding school for girls in Belgrave Gate. Mary was to run the school herself for many years.

She was a respected needlework artist who received worldwide recognition for her embroidered copies of well-known paintings by artists such as Gainsborough and Raphael. Appropriately for a craftsperson based in Leicester, Mary worked in wool that was dyed locally. To create the texture of brushstrokes, she employed a technique which used both long and short stitches, and silk thread to enhance the highlights.

She was an enthusiastic patron of the arts, encouraging other local artists including John Flower. Mary's association with education was recognised in the name of a local girls' school that later became the Mary Linwood Secondary School, and finally a comprehensive school. It closed in 1997. The site is now occupied by the Samworth Academy.

Mary Linwood died on 11 March 1845. She was buried in St Margaret's church in Leicester, which she had attended for many years, at the east end of the south aisle. She exhibited in London, Liverpool, Glasgow, Dublin and elsewhere right up until her death. Today, examples of her fine work can be seen at the Victoria and Albert Museum in London, and at the New Walk Museum and Art Gallery in Leicester.

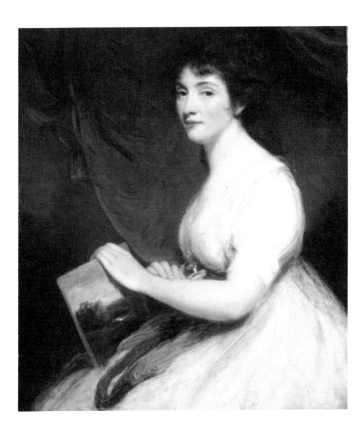

Mary Linwood by
John Hoppner.

## 19. WILLIAM CAREY, 1761–1834
### Baptist Missionary and Bible Translator

The founder of the Baptist Missionary Society, William Carey moved to Leicester in 1789 from his native Northamptonshire, to become the minister of the Harvey Lane chapel. The church was located on the corner of Harvey Lane and Thornton Lane, and for the four years he remained in the town; he lived in a small cottage opposite the church, supplementing his income by shoemaking and running a small school.

The Harvey Lane chapel was destroyed by a fire in 1921. It was rebuilt as a Memorial Hall but demolished in 1963. His cottage was removed at the same time to make way for the Southgates Underpass and Holiday Inn development. The various relics that had previously made up a small museum in Carey's Cottage are now at the central Baptist church in Charles Street. The elevated footpath between the Holiday Inn and the St Nicholas Circle multistorey car park is named Harvey Walk, and follows the approximate line of the former Harvey Lane. There is a commemorative plaque referring to the site of Carey's Cottage near the Holiday Inn's reception.

He was mainly self-taught, but became fluent in Greek, Latin and Hebrew, as well as being knowledgeable in science and history. While in Leicester he wrote *The Enquirer*, which is still regarded as the finest missionary treatise ever written. The Baptist Missionary Society was founded in 1792, largely as a result of Carey's influence, and in 1793, he travelled with his family to India. He worked as a foreman in an indigo factory in Calcutta until setting up a church there, before moving on to Serampore in 1799.

William Carey 1761–1834.

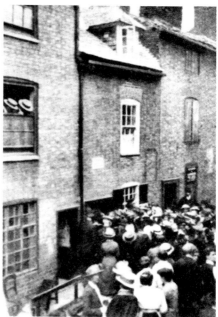

The opening of the Carey Museum in Harvey Lane in 1915.

He was made Professor of Sanskrit and Bengali at Fort William Cottage in Calcutta in 1801 and in 1805 opened a mission chapel there. He was a prodigious translator, partly responsible of translating the Bible into six Indian languages, and the New Testament into twenty-three more. He died at Serampore in 1834.

## 20. SUSANNA WATTS, 1768–1842
## Campaigner for Human Rights and Social Justice

Susanna Watts was a passionate, tenacious and brave campaigner for human rights, who was remarkably successful in challenging the social attitudes of her time. She was born in Leicester at Danet's Hall (*seen below around 1791*), and was the daughter of John Watts and the niece of Revd William Watts, whose own campaigns had brought about the building of the Leicester Royal Infirmary.

Susanna dedicated her life to the immediate abolition of slavery. She also launched one of the first 'fair trade' campaigns by attempting to persuade local shopkeepers not to use or sell sugar that had been produced in the Caribbean. She believed that if the boycott was wide enough, it would mean the end of West Indian slavery.

She was a skilled writer and began earning money through writing when only fifteen years of age. She wrote poetry that promoted feminism and the emancipation of slaves; she also criticised the anti-feminist views of the time. She also produced Leicester's first guidebook, which was published in 1804.

Some of Susanna's original work has survived and is now held at the Record Office for Leicestershire, Leicester and Rutland. After William Wilberforce had commented that anti-slavery campaigning was not a suitable activity for women and should best be left to men, Susanna responded with poetry:

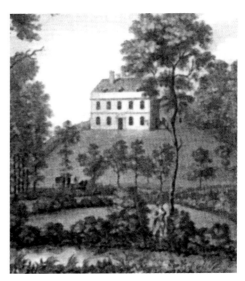

On a Gentleman saying that,
Some ladies, who were zealous in the
Anti-Slavery Cause, were brazen faced.
Thanks for your thought – it seems to say.
When ladies walk in Duty's way,
They should wear arms of proof;
To blunt the shafts of manly wit –
To ward off censure's galling
And keep reproach aloof:-
And when a righteous cause demands
The labour of their hearts and hands,
Right onward they must pass,
Cas'd in strong armour, for the field –
With casque and corselet, spear and shield,
Invulnerable brass.

Susanna lived in a house on London Road for many years, but towards the end of her life moved to King Street. She was buried in the churchyard of St Mary de Castro.

## 21. ELIZABETH HEYRICK, 1769–1831
### Social Reformer and Campaigner

Elizabeth Heyrick, a close friend of Susanna Watts who shared many of her beliefs and motivations, was an energetic and deeply committed campaigner against slavery.

She was the daughter of a prominent Leicester textile manufacturer, John Coltman, and married John Heyrick, a lawyer who was of the same family as the poet Robert Herrick. He died when Elizabeth was only twenty-five years of age, and for the rest of her life she committed herself to her radical activist principles.

Her father was a leading Unitarian, but Elizabeth became a member of the Methodist church after a visit by John Wesley. After her father's death, she chose to become a Quaker.

She helped to form a Ladies Association in Birmingham and in Leicester organised a boycott of sugar from the Caribbean with Susanna Watts. Her many campaigns included prison reform, to which end she worked as a prison visitor, the abolition of capital punishment, and electoral reform. She once prevented a bull-baiting contest by purchasing the bull.

## 22. WILLIAM GARDINER, 1770–1853
### Composer and Musicologist

The son of a Leicester hosiery manufacturer, William Gardiner was a man of considerable musical talent. At the age of six he sang a solo at the wedding of a family friend, and when still in his early teens he composed two pieces for brass bands performed in Leicester's market place.

Gardiner's boyish enthusiasm for music enabled his home town to be the first place in England to hear the music of Beethoven. He was also a strong admirer of the works of Joseph Haydn, and in 1804 he commissioned his own hosiery factory to produce six pairs of cotton stockings, in which quotations from Haydn's music were worked. Apparently, the stockings were sent to the composer but were lost in transit.

In 1808, he published his first composition, *Sacred Melodies*, which comprised passages from the works of German composers including Beethoven, Haydn and Mozart, to which Gardiner had put the words of psalms. In 1832, he wrote *Music of Nature* and in 1836, the first part of his autobiographical *Music and Friends*. He was elected a Member of the Institut Historique de Paris, despite having been deported from that country some years earlier for expressing his liberal views.

Gardiner was also well known for his ideas on acoustics and travelled widely to advise on the design of new concert halls. In 1850, he advised the architects of the Brighton Pavilion on the best place to locate the organ.

## 23. NATHANIEL CORAH, 1777–1832
### Textile Entrepreneur

The Corah family lived in Leicestershire since before 1600 and, by 1800, like many villagers, the family in Bagworth, in the north-west of the county, had combined framework knitting with their farming enterprises. Nathaniel Corah was born in 1777. He had trained

as a framesmith, and while still in his twenties, established a small textile business in the nearby village of Barlestone.

The deterioration in the country's economy forced Nathaniel into debt. Although he sought to negotiate and promised to pay back all he owed, one of his creditors demanded his money. Nathaniel faced legal action and was imprisoned. On his release, anxious to pay his way, he became a worker in a gun factory in Birmingham. Two years later, when finding he was once again unemployed, Corah saw the potential for a new business. While he had been in prison, his wife and children had lived in Leicester. He saw there the growth in small stockingers and, at the same time, the dramatic growth in the working class population of Birmingham.

He began buying items of clothing from the Leicester manufacturers, conveying them for sale to markets in Birmingham. By personally selecting each item, he was able to establish a high level of quality control that became recognised by his customers. On Saturday mornings, he would purchase goods offered to him at the Globe Inn in Leicester's Silver Street, which he would then transport to a small warehouse in Birmingham's Edgbaston Street.

The project was a success and by 1824, Corah was able to acquire a block of buildings in Leicester's Union Street, which were extended in 1827. This factory unit pioneered in the city the concept of organised production management. In 1830, Corah's sons, John, William and Thomas, joined the business, which was then trading as Nathaniel Corah & Sons. This far-sighted move ensured the firm's future development because just two years later, Nathaniel Corah died at the age of fifty-one.

In his later, more prosperous years, Nathaniel Corah had been able to pay all the debts that had led to his imprisonment as a young man. However, he refused to make good just one debt – the man who had refused to listen to Corah's pleas in 1815 and had demanded his arrest.

The next twenty years saw continued success for the company, its expansion requiring a move to a purpose-built factory in Granby Street (next to the present empty HSBC bank), and then to the famous St Margaret's works on a 4-acre site near the ancient St Margaret's church. The foundation stone for this factory was laid by Edwin Corah, Thomas's son, on 13 July 1865, heralding the start of Corah's greatest years. One year later, Edwin's sister, Jennie Corah started the massive beam engine that provided the factory's power, the first textile factory in Leicester to be designed for integral steam-driven power.

By 1866, over 1,000 people were working at St Margaret's, and the buildings had been extended twice. The architect of the first part of the St Margaret's complex was William Jackson of Lowesby Lane in Leicester. Originally, a factory yard stretched north as far as the canal, but by 1941 there had been no less than nineteen extensions to the original building, taking up all available land.

At the time of the move from Granby Street, the company had adopted an image of St Margaret as their emblem. She was a most appropriate symbol with her association with wool, a shepherdess martyred in AD 275. The emblem was patented by the company on the very first day of the 1875 Trade Marks Registration Act, and is therefore the oldest trademark for knitted goods in the world.

For many years, her statue, which some say is weeping, stood proudly on a plinth high on the external wall of the factory, facing the present Vaughan Way. After the demise of the company and the sale of the buildings in the 1990s, she was removed, first to the central courtyard and finally to the churchyard of St Margaret's parish church facing St Margaret's Way in 2008.

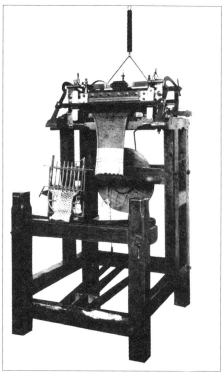

*Above left:* Nathaniel Corah, 1777–1832.

*Above right:* Nathaniel Corah's stocking frame, still in the family's possession.

The West Bridge terminus of George Stephenson's Leicester to Swannington Railway.

## 24. GEORGE STEPHENSON, 1781–1848
## Railway Engineer

George Stephenson was not an inventor. He did not invent the steam engine or the railway locomotive, or the concept of moving wheeled trucks along tracks. Yet he is rightfully regarded as the 'father of railways', and as the man who enabled England to lead the world in the construction of rail transport, thus fuelling the English Industrial Revolution.

Stephenson's contribution to the development of Leicester was the Leicester to Swannington Railway, which he designed and constructed. He drove the first train to travel along the line, and his commitment to the area is shown by the fact he lived near the line for many years.

Leicester was one of the first towns in the country in which a railway line was constructed. Stephenson's line between Stockton and Darlington opened in 1825, and its success encouraged other areas of the country to reconsider earlier opposition to railway development. Stephenson's Liverpool and Manchester Railway opened in 1830, but by then, he and his son Robert were already in discussion with landowners, mine owners and engineers in Leicestershire, with a view to constructing a line that would link the coalfields of north-west Leicestershire with the town of Leicester.

Their first meeting with the businessmen of the town, led by William Stenson, a mining engineer from Coleorton who developed Whitwick Colliery and was regarded as the 'founder' of the town of Coalville, took place at the famous Bell Hotel in Humberstone Gate. The detailed and serious discussions that took place resulted in the opening of the Leicester to Swannington Railway just two years later on 17 July 1832, although the line did not reach Swannington until a year later.

A transport link from the mines in north-west Leicetershire was much needed to enable coal to be brought into the town and then taken onwards to the major residential and industrial areas. The Leicestershire pits were in fierce competition with those in neighbouring Nottinghamshire, which had the benefit of a canal network for transporting the extracted coal. Attempts to develop a similar network in Leicestershire had collapsed with the failure of the Charnwood Forest Canal. Carrying such a heavy commodity as coal by road was difficult, as for many months of the year the carts would find the heavy clay of Leicestershire unable to bear the weight. Indeed, the eventual construction of the line was similar in method to that of the canals, in being a series of relatively level sections of track connected by short inclines (as in the locks of the canal system) where trucks were winched from one level to the next by rope.

The Leicester terminus of the line was beside the wharf at West Bridge, where coal could be transferred to the Soar navigation. Today, the area is dominated by the road traffic system of St Nicholas Circle around the Holiday Inn, indicative of the dominance of the motor vehicle since the latter decades of the twentieth century. The canal is still evident, and some Victorian factories and mills have survived along the route of the waterway.

The remnants of that first railway terminus can still be seen, close by the canal, near to Tudor Road and King Richard III Road, but it is now an inauspicious memorial to a great engineering achievement, neglected and marred by vandalism and graffiti. The surviving platform is original, from when the railway's owners decided to carry passengers, and the track bed is now a public footpath, running for about one mile towards the Glenfield tunnel.

25. JOHN ELLIS, 1789–1862
**Businessman and Quaker Reformer**

The path through time of Leicester's economic and social development has been influenced on many occasions by businessmen with a sense of social responsibility, and often combining a liberal Christian belief such as demonstrated by the Unitarians and the Quakers.

John Ellis was both a Quaker and a significant liberal reformer, and his influence on the town of Leicester came through his roles as both a town councillor and MP.

He was instrumental in contacting George Stephenson, persuading the engineer that a railway line linking Leicester and the coalfields of north-west Leicestershire was a viable proposition, and he drew together the businessmen who were able to fund the project. He was, for some time, a director of the Midland Counties Railway and its successor, the Midland Railway.

But Ellis was also active in the field of social justice. He attended the World Anti-Slavery Convention in London in 1840, and his presence is recorded in a painting, which is now in the National Portrait Gallery.

John Ellis, 1789–1862.

## 26. JOHN FLOWER, 1793–1861
### Artist

Known by many as the Leicestershire Artist, John Flower was baptised in the parish church of St Mary de Castro in October 1793. He came from a family who owned the Castle Mill, below the church and castle on the River Soar, for several generations. Both the mill and the mill's shop in the Saturday market were bequeathed to Jane Flower in 1748 by Thomas Carter, a descendant and heir of the MP Lawrence Wright, who purchased the mill from the Leicester Corporation in 1685. The Flower family still held the mill in 1843 according to Thomas Cook's *Guide to Leicester* but a new miller, one Joseph Pywell, was occupying the premises by 1845, according to Thomas White's *Directory of Leicester*.

By Flower's time, the family had suffered a decline in status owing to his father's early death, and they were earning a living as woolcombers. In 1806, at the age of thirteen, Flower was apprenticed to a framework knitter, but his potential artistic talent was noticed by Mary Linwood who, in 1816, arranged for Flower to receive lessons from Peter de Wint (1784–1849) in London.

On returning to Leicester as a qualified artist, Flower was able to work as a drawing teacher from his own home in Marble Street. He charged a fee of one guinea a week for two lessons in the student's home, or three lessons at his house.

Flower married Frances Clark in 1813. A daughter, Elizabeth, was born in 1816, but two further children died in infancy.

Flower worked chiefly in watercolours, pencils and wash. Although Flower's landscapes are characterised by their true reflection of nature, with inimitable foliage, rock scenery and excellent colouring, his main forte was architecture. John Flower's pictures of buildings are seen by many to be without equal. Indeed, were it not for Flower's drawings of the town (published in *Views of Ancient Buildings in the Town and County of Leicester* in 1826) the knowledge we have today of the buildings and architectural character of eighteenth-century Leicester would not be nearly so great.

In 1827, Flower moved to Southgate Street. He may have kept a studio there after moving to New Walk in about 1842. Nine years later, he moved again into his newly built home at No. 88 Upper Regent Street (now No. 100 Regent Road), which was designed for him by the well-known Leicester-based architect Henry Goddard. This building is a substantial double-fronted, neo-Jacobean structure, which is now used as business offices.

In 1827, he was invited to take up the post of drawing master at the Proprietary School in New Walk (which is now the main building of the Museum and Art Gallery, which holds some of his work). Flower turned down the appointment but did accept teaching roles at a school in Ullesthorpe, and at Ratcliffe College in Syston.

Flower was known as a good-natured and friendly man. His output was considerable, and, with his wife, he travelled to neighbouring counties and as far as North Wales in search of subject matter.

He died on 29 November 1861 at his home. A blue plaque commemorates the building's association with the artist. He was buried in Welford Road cemetery; the funeral service was conducted by Revd Charles Berry of the Great Meeting, where Flower had been a member for over forty years.

*Left*: John Flower, 1793–1861.

*Below*: John Flower's residence at No. 100 Regent Road, Leicester, designed by himself and architect Henry Goddard.

# 1800–1900

## 27. JOHN ELLA, 1802–1888
### Music Entrepreneur

A man with a shrewd business sense as well as a sensitive love of music, John Ella was the son of a Leicester confectioner who achieved middle-class status and numbered Hector Berlioz, Giacomo Meyerbeer and Gioacchino Rossini among his close friends.

Ella used the experience of his father's small shop to develop his own commercial model, becoming a concert manager who would hire performers from across Europe, arrange the venues for concerts, and attend to almost every detail of each musical event, including writing the programme notes.

He was an accomplished violinist and composer. As a music critic, he wrote for *The Morning Post*, *The Athenaeum* and *The Musical World*, but his major contribution to the musical world of the nineteenth century was the Music Union, a society dedicated to high standards of performance of instrumental and chamber music. Ella founded and directed the Musical Union, and his own sensitive appreciation of music in performance enabled him to maintain the highest standards. He was a dynamic and intelligent man who throughout his career was able successfully to survive economic and political change. From a relatively humble family background, he achieved respect, wealth and status, not only in his home town but in the capital cities of Europe. He was buried in St Martin's churchyard in Leicester.

## 28. THOMAS COOPER, 1805–1892
### Poet and Chartist

Thomas Cooper was the illegitimate son of a man who worked as a dyer in Leicester. After his father's death, at a comparatively young age, he moved with his mother and half-sister to Gainsborough, where Cooper became an apprentice to a shoemaker.

Although having very little formal education, Cooper had an almost fanatical urge to learn and to improve his literacy. His amazing self-discipline meant that by the time he reached adulthood he could read Latin, Greek and French texts, and could recite many thousands of lines of poetry and prose, including the first three books of Milton's *Paradise Lost*.

Cooper became a schoolmaster in 1827, and then a Methodist preacher, but in order to secure an adequate income he looked to writing as a career, working first on a newspaper in Lincoln and then, in 1839, as an assistant to a second-hand bookseller in London. A year later, he returned to his home town to work on *The Leicestershire Mercury*, but his

growing Chartist principles forced him to resign some months later. He became a prominent and active supporter of the Chartist movement, including editing the Chartist journal, *The Midlands Counties Illuminator*.

The Chartist movement reached its peak in 1842 when, set against a backdrop of an economic downturn, a petition of over 3 million signatures demanding reforms through the six fundamental principles of the 1838 People's Charter was rejected by Parliament. Workers went on strike in fourteen English counties.

Cooper played a leading role in the Staffordshire pottery riots. He travelled to Hanley in Stoke-on-Trent and delivered a number of 'inflammatory' sermons, being described in one record of that time as 'a talented Chartist orator from Leicester'. The riots were initially a working-class response to one mine owner's decision to force a considerable reduction of wages on his employees. They led to the burning of houses and attacks on a police station, rectory and post office in the Stoke area. Wider strikes and riots were to follow across most of Staffordshire. Nearly 1,500 workers, including leading members of the Chartist movement, were arrested. Some 250 were sentenced to terms of imprisonment or to transportation. Cooper was arrested and imprisoned in Stafford Gaol for two years.

Cooper continued to write and publish many works. His collection of short stories *Wise Saws and Modern Instances*, first published in 1845, is regarded his finest and offers vivid accounts of the suffering of the impoverished stockingers in Leicester of that period. He provided the author Charles Kingsley with a wealth of information about Chartism in the working classes, being the basis for Kingsley's Chartist 'poet of the people' in his novel *Alton Locke*.

Thomas Cooper died in Lincoln in 1892. In his later years, he rejected many of his earlier beliefs and turned to lecturing on Christian principles. His friends knew him as an intelligent, hard-working, generous and honest individual; but he was also a man who could be stubborn, who disliked being challenged, and who may well have died believing that he had achieved little in his complex lifetime.

## 29. THOMAS COOK, 1808–92

At precisely the time when the Chartists were seeking political reform in order to improve the lives of working-class people in the industrial towns of the Midlands and the North, the young Baptist preacher Thomas Cook became convinced that temperance was the answer to many of the social problems of the time. The Temperance movement began in America, and became popular in the UK as a result of the activities of the Revd John Edgar, a Presbyterian minister in Ireland. In England, it was the evangelical Baptist churches who embraced the cause.

Thomas Cook was born in Melbourne in Derbyshire, and after working as a travelling missionary across several counties in the East Midlands, he married the daughter of a farmer from Rutland and settled in Market Harborough. It was while travelling from Market Harborough to Leicester to attend a Temperance rally that his idea of using the developing railway system to help social reform emerged. 'The thought suddenly flashed across my mind', he later wrote, 'as to the practicability of employing the great powers of railways and locomotion for the furtherance of this social reform.'

At the meeting in Leicester, Cook proposed that a special train be hired to take Temperance supporters to a meeting in Loughborough, which was being held about a month later. He

contacted Midland Railway on the following day, and on 5 July 1841 nearly 500 local people undertook the journey from Leicester's Campbell Street station to Loughborough and back. The event was not only successful in social terms, but also as a financial proposition, as the excursion created a profit. Cook later commented: 'thus was struck the keynote of my excursions, and the social idea grew upon me.' For the next four years, Cook organised many similar excursions, which provided thousands of workers in the towns of the Midlands their first experience of railway travel, and offered them an environment away from the lure of alcohol.

Cook's first commercial venture, an excursion from Leicester to Liverpool, took place in 1845. Setting the standards for his future business success, he planned each aspect of the project in great detail, personally travelling the route beforehand and writing a handbook for passengers to read during the journey. His careful attention to detail and his ability to find ways of effectively advertising the low cost of tickets ensured that the venture was an outstanding success, and the first step towards a tourism business of international renown.

## 30. REVD DAVID VAUGHAN, 1825–1905

The religious, philanthropic and educational work of the Vaughan family in Leicester has been described as 'the most beautiful chapter in the history of the Church of England in the nineteenth century'. David Vaughan was the grandson of Dr James Vaughan, who had played a major role in drawing up the original rules of the Leicester Royal Infirmary. His father was the vicar of St Martin's Leicester, and his mother was the daughter of the well-known banker John Pares. Vaughan also became the vicar of St Martin's, following in the footsteps of his father and two of his brothers.

He was educated at Leicester's Collegiate School and then at Rugby before winning a scholarship to Trinity College, Cambridge. He returned to Leicester after his ordination, to serve as a curate to his brother at St Martin's before becoming the vicar of St Mark's, Whitechapel in London.

During his time in London, Vaughan was able to observe the social and reforming work of a number of liberal theologians and preachers, and in 1854, brought many of those concepts back to his home town in the form of a new educational facility for working men.

Initially, an institute with a reading room was set up in a parish school, and classes and lectures presented by volunteers were arranged. In 1868, with over 400 regular adult attendees, the institute became a college. During Vaughan's lifetime, the Leicester Working Men's College grew to a membership of 2,300 students, with a provident society, a sick benefit society and a book club. Many of the college's students went on to become prominent figures in local commerce and politics.

Vaughan led his college as president for over forty years. In 1893, he resigned from the parish of St Martin's and retired to Wyggeston's Hospital where he was the master. He died at the hospital in 1905, and was buried in Welford Road Cemetery. In 1908, a new college building, funded by public subscription, was erected in Great Central Street, and the institute was renamed Vaughan College in honour of its founder. This was in turn replaced by a modern building, integrated with the Jewry Wall Museum in 1962.

In 2013, Leicester University, which has been operating Vaughan College since 1929, announced the closure of the Jewry Wall building and its intention of transferring its courses

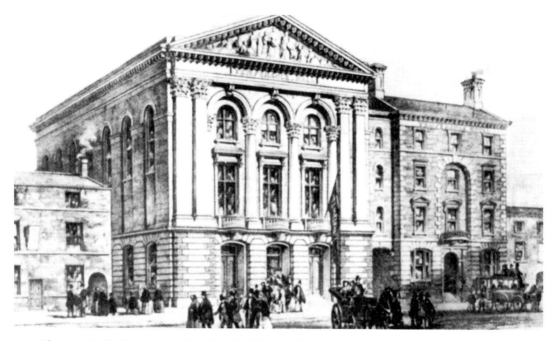

Thomas Cook's Temperance Hotel and Hall in Granby Street.

The Revd David Vaughan, 1825–1905.    The Vaughan Porch, Leicester Cathedral.

to the main university campus. David Vaughan, his father and brothers – the four Vaughan vicars – are commemorated by the Vaughan Porch of Leicester Cathedral.

## 31. JAMES THOMPSON, 1817–1877
### Journalist, Editor and Historian

James Thompson followed his father into the newspaper profession, but his political views were strongly influenced by his education at the Great Meeting in Leicester under its minister Charles Berry. He rose from being a reporter for his father's *Leicestershire Chronicle*, the leading local Liberal journal of the time, to being its leader writer, then joint owner with his father, and later the sole proprietor. He then consolidated the newspaper's position by purchasing the copyright of the *Leicestershire Mercury*, with which he merged the *Chronicle*.

Thompson's most radical period was before he took on the mantle of newspaper editor. In the 1830s, he supported philosophies of Robert Owen and would debate social issues at the Owenite Social Institution in the market place. He then joined the Owenite community at Manea Fen in Cambridgeshire soon after its founding by William Hodson, which became one of the most radical of the Owenite communities. There, Thompson edited the community's own newspaper *The Working Bee*.

In Leicester, Thompson continued to support Liberal principles and worked towards the repeals of the Corn Laws, the abolition of church rates and the extension of the electoral franchise, but politically he was seen to move away from the more radical Chartists elements.

He had a life-long interest in archaeology and antiquities, publishing a number of significant works on history. He was a founder of the Mechanic's Institute in Leicester, and of the Leicester Historical & Archaeological Society. He wrote many articles for that society's 'Transactions', and was an honorary curator of the town's museum. In 1847, assisted by William Kelly, he reorganised the manuscripts in Leicester's Muniment Room, which had for some years been in a state of disorder. He was also the local secretary of the Society of Antiquaries, and a fellow of the Royal Historical Society. He died at his home in Fosse Road, Leicester, in 1877, and was buried in Welford Road cemetery.

## 32. MATTHEW TOWNSEND, 1817–1879
### Inventor of the Latch Needle

Until the mid-nineteenth century, the knitting industry was based upon the original hand frame invented by William Lee in 1589. This machine, although relatively slow, produced stocking stitch fabric that could be varied in width. Using 'bearded' needles, the frame could make both socks and stockings.

Matthew Townsend's invention of the latch needle in 1847 changed the industry dramatically by enabling the rapid development of faster and more productive circular knitting.

Townsend was born in Cropston in Leicestershire. His father was a framework knitter, and by the age of nine or ten years he became apprenticed in the same trade. By the age of twenty, he had moved to Leicester where he began producing luxury items within the hosiery market, including cravats, shawls and gloves. His business enterprise led him to become the owner of two hosiery factories, managing a workforce of more than 400 employees.

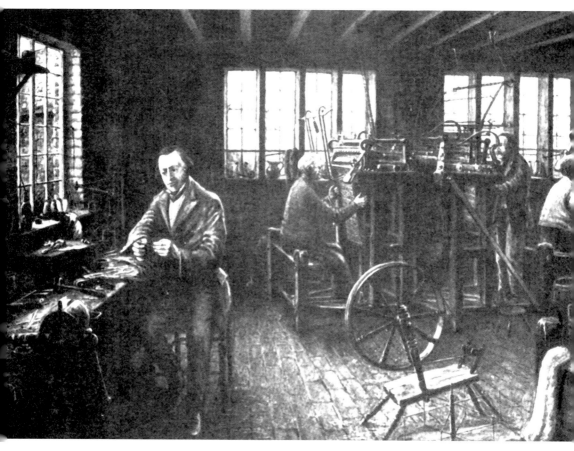

A painting by Albert Findley of the invention of the latch needle by Matthew Townsend in 1849. The scene is modelled on Thomas Chamberlain's frame smith's shop in Gladstone Street.

Townsend's design was based on an earlier device, which had been patented in 1806 in France by Pierre Jeandeau but had never been developed into a successful working needle. Townsend improved Jeandeau's original design and patented his modifications. However, in 1857, as a result of a series of reckless business deals, Townsend lost much of his money and was declared bankrupt. He paid off his debts by selling his possessions and chose to begin a new life in America, settling in Massachusetts, where he went into partnership with a local garment manufacturer, Charles Draper. This enterprise also failed because it was found that the American version of the latch needle had been patented some months before Townsend's version. Townsend was sued for patent infringement and his new company was auctioned off. The Draper side of the partnership continued to prosper, and the same company is still operating today from the same site.

Little is known of Townsend's later life. Before moving to America, he married Maria Howe and had six children. While in America he married Clara Foster, with whom he had further children. It is not known whether his first wife died or whether they were divorced. He later returned to England, but his descendants still live in Canton area of Massachusetts.

## 33. ALFRED RUSSEL WALLACE, 1823–1913
## Naturalist, Explorer, Anthropologist and Geographer

It is remarkable that one of the greatest English naturalists, whose work both complemented and challenged that of Charles Darwin, should be almost unknown in the town where the academic foundations of much of his later groundbreaking research are to be found.

Born in Monmouthshire, Wallace came to Leicester to teach drawing, mapmaking, and surveying at the Collegiate School. It was in Leicester's public library that he met Henry Bates, a chance encounter that led to a close friendship and ultimately to a joint expedition to the Brazilian Amazon.

Wallace independently discovered the principle of natural selection in 1858. Darwin published his *On the Origin of Species* in the following year. In many accounts of the development of evolutionary theory, Wallace is mentioned only in passing, usually as simply being the stimulus to the publication of Darwin's own theory. In reality, Wallace had developed his own distinct evolutionary view that diverged from that of Darwin, and was regarded by many, including Darwin, as a leading thinker on evolution in his day.

Darwin and Wallace exchanged knowledge and stimulated each other's ideas and theories over many years. He is the most cited naturalist in Darwin's *Descent of Man*. Wallace remained an ardent defender of natural selection for the rest of his life. By the 1880s, evolution was widely accepted in scientific circles, but Wallace was almost alone among prominent biologists in believing that natural selection was the major driving force behind it.

He died in 1913. *The New York Times*, in its obituary, described him as 'the last of the giants belonging to that wonderful group of intellectuals … whose daring investigations revolutionised and evolutionised the thought of the century'.

## 34. HENRY WALTER BATES, 1823–1892
## Naturalist

Unlike his close friend and fellow scientist of the natural world, Henry Bates was born in Leicester. He was born into a literate middle-class family, and, again like Wallace, received little formal education. By the time he was twelve years of age, he was apprenticed to hosiery manufacturer, but in his spare time he studied at the Mechanic's Institute and collected insects in the Charnwood Forest.

The meeting with Wallace at Leicester's town library led to collaboration and their 'great adventure' in the Amazon rainforest.

In April 1848, they left for Pará, near the mouths of the River Amazon. Wallace returned to England in 1852, barely escaping with his life after his ship had caught fire and sank. Bates remained in Brazil for eleven years, discovering what is now known as Batesian mimicry. He realised that some harmless butterflies had become adapted to mimic the colouration of poisonous butterflies, and so were less likely to be eaten by birds that had learned to avoid the poisonous ones. Fieldwork and scientific investigation extending Bates' work continues to this day. He took three years to write up the research and findings from the expedition in *The Naturalist on the River Amazon*, which is still regarded as one of the finest report of natural history.

The Museum and Art Gallery in Leicester's New Walk.

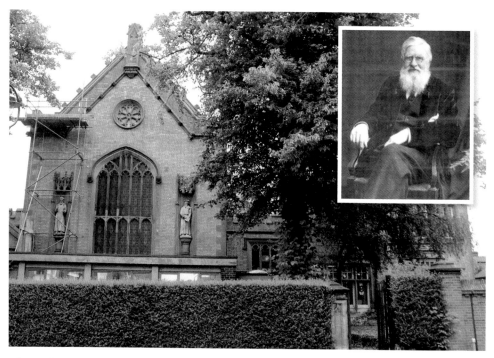

The Collegiate School in College Street, Leicester. The inset shows Alfred Russel Wallace, 1823–1913.

Henry Bates, 1825–92.

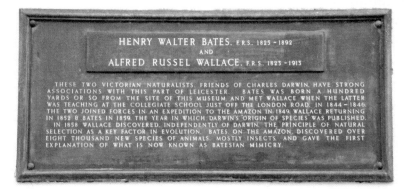

The plaque outside New Walk Museum, commemorating the work of Alfred Russel Wallace and Henry Bates.

## 35. STEPHEN TAYLOR
## Organ Builder

The Taylor family had been building organs since around 1855, and Stephen Taylor established his business in 1866, based in Severn Street and Nelson Street. The organ at Scraptoft parish church is an example of one Taylor's earlier instruments.

In all, the company built some 300 organs and 3,000 organ blowers. Most of their instruments were for venues in Leicestershire and the surrounding counties, although instruments were also built for as far afield as Yorkshire, Hampshire, London, Worcester, Staffordshire and Warwickshire.

Leicester churches that had Taylor organs include St James the Greater, St John the Divine, St John the Baptist, Victoria Road Baptist, Stoneygate Baptist, St Peters and St Saviour's Highfields, St Michael's, Knighton, and the church of Christian Science in Granville Road.

Quality was the hallmark of Taylor's instruments. They were built of good quality materials, and were noted for their easy access for repair and maintenance.

The organ at the De Montfort Hall is considered to be the last surviving example of a Taylor-built concert organ. It was commissioned and paid for by Sir Alfred Corah, and completed in 1913. After hearing an inaugural recital, Corah wrote the following to the Taylor Company:

> I have pleasure in sending you the enclosed cheque in payment for the new organ at the De Montfort Hall. I consider your charges are most reasonable, and wish to assure you that the work has given me the greatest satisfaction – in fact it could not have been better had I gone to the finest builders in London. All the great organists who have tried it are delighted with the instrument.

DE MONTFORT HALL,
LEICESTER.

Wednesday Evening, February 18th,
AT 8 O'CLOCK.

Private Recital

ON THE
NEW CONCERT ORGAN
BY
Mr. Cardinal Taylor
(MUS. BAC., F.R.C.O.)

Songs will be given by Mrs. Reg. Corah
and other friends.

Mr. CHARLES HANCOCK, Mus. Bac. Oxon.,
has kindly consented to play one piece, and has
also undertaken to act as Honorary Adviser with
respect to the Organ, pending the Appointment of
an Organist by the Corporation.

The former offices of Stephen Taylor & Sons (organ builders) in Severn Street, Leicester, and the programme cover for the inaugural recital of the De Monfort Hall Organ, 1913.

## 36. THOMAS FIELDING JOHNSON, 1828–1921
Businessman and Philanthropist

The life of Thomas Fielding Johnson is a very Victorian story of a man who acquired wealth and social status through hard work and commitment, and who was genuinely philanthropic in his gifts to the town of Leicester.

He was born near Mansfield in Nottinghamshire, but came to Leicester at the age of twelve to attend the Nonconformist Proprietary School in New Walk. He was adopted by his aunt and uncle who lived in Leicester and had no children of their own and, by the age of twenty-four, on the death of his adoptive father, he inherited the family's textile business.

He married Julia, the daughter of Thomas Stone, town clerk to the newly reformed corporation of Leicester, became a town councillor and a JP, and served as a special constable and a prison visitor. As well as being a very successful businessman with factories in Leicester (West Bond Street and Abbey Mills) and in Nuneaton, he was also a governor of the Leicester Royal Infirmary and a member of the Leicester Volunteer Rifle Corps. He was granted Honorary Freedom of the City of Leicester in 1919, his ninety-first year.

His major gift to the town was the old Leicester Lunatic Asylum and its grounds that he purchased and donated for the creation of a University College, which became the Leicester University of today.

From 1869 until his death in 1921, Fielding Johnson lived at 'Brookfield' on London Road, which later became the home of the bishops of Leicester, and then the Charles Frears School of Nursing. In 2012, it was sold (by De Montfort University) to Leicester University to be used for student accommodation.

The Fielding Johnson Hospital on Regent Road in Leicester, now converted into offices, was set up by Thomas Fielding Johnson junior. In 1925, he purchased three adjoining houses that had been designed in Georgian style by William Flint in 1844, and combined them into a hospital. The original County Asylum building on the Leicester University campus is now known as the Fielding Johnson Building.

## 37. SIR ISRAEL HART, 1835–1911
Civic Leader

Born in Canterbury, Israel Hart came to Leicester in his youth to become the senior partner in the large Leicester firm of Hart & Levy, who were wholesale tailors and clothiers. Their factory and offices, known as the Wimbledon Works, were located in Southampton Street near to where Leicester's Curve Theatre now stands.

He joined the Corporation in 1874, representing the East St Margaret's Ward, and was elected an alderman in 1885, and served as mayor on four occasions. From 1878 to 1884 he was high bailiff of the borough.

Hart was a popular man who worked hard to improve local social conditions. He set up the first branch of the Free Library in Garendon Street in the ward he represented, and provided the impressive fountain in Town Hall Square.

He was knighted by Queen Victoria in January 1895 and retired from public life to live in the Holland Park area of London, where he died in 1911.

The former Fielding Johnson Hospital, established by Thomas Fielding Johnson junior from houses designed by William Flint.

Brookfield in London Road, Leicester. Thomas Fielding Johnson's home from 1869 to 1921.

A very early photograph of Leicester's Town Hall Square with Israel Hart's fountain.

Town Hall Square and Israel Hart's fountain during the Second World War.

## 38. JOSEPH GODDARD, 1840–1900
### Architect

Joseph Goddard was the third generation of the family to become an architect. His father, Henry Goddard, was born in 1792. His grandfather, also Joseph Goddard, who was born in 1751, had moved from Kirby Muxloe to live and work in the Belgrave Gate area of the town.

Henry's first acknowledged work was in 1817 when he designed some tenements in Belgrave Gate for his father. Various other houses and farm buildings followed, including the Fish and Quart pub in 1832.

Joseph Goddard junior became a partner in the family firm in 1862, having been articled to his father since the age of sixteen. His father died in 1862, leaving Joseph in business by himself. However, the firm prospered and Joseph produced many fine buildings in the period that followed, including many local schools, Leicester's most iconic structure the Clock Tower in 1868, and the gentle but formal parish church at Tur Langton in 1865/66.

He became a fellow of the Royal Institute of British Architects in 1871, the same year he designed Tintern House. His headquarters for the Leicestershire Banking Company in 1872/73 marked the high point in his career. He went on to become president of the Leicester and Leicestershire Society of Architects.

Joseph's son, Henry, joined the practice in 1888. The family inheritance continued with his son, also named Henry, and most recently, with Anthony Goddard.

Tur Langton parish church, designed by Joseph Goddard; an urban church in a rural setting.

## 39. WILMOT PILSBURY, 1840–1908

### Artist and First Headmaster of the Leicester College of Art

Wilmot Pilsbury was born in Dorking, Surrey, and studied at the South Kensington School and the Birmingham School of Art. He became the first headmaster of the Leicester School of Art in 1870, and stayed for ten years.

He was made an associate of the Royal Watercolour Society in 1881, and elected to the Royal Birmingham Society of Artists in 1890, becoming a full member of the Royal Watercolour Society in 1898.

The composition, quality and attention to detail have made his works extremely popular, and today they are keenly collected and have risen in value quite dramatically. He specialised in cottages, churches, landscapes and rural scenes, including gardens.

He worked with the Leicester architect Isaac Barradale in designing his own house in the Stoneygate area of Leicester, providing some of the intricate external decoration. The house incorporated an upper artist's studio, which was designed to make full use of the natural light.

He died in 1908 and a Memorial Exhibition was held at the Fine Art Society, London, in the same year. Examples of his works may be seen at the Brighton Art Gallery of Brighton and Hove Museums, Leicestershire Museums, Maidstone Museum and the Castle Museum in Norwich.

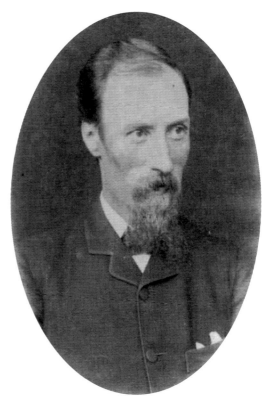

Wilmot Pilsbury, 1840–1908, and Wilmot Pilsbury's Stoneygate house, designed by Leicester's Isaac Barradale.

## 40. ISAAC BARRADALE, 1845–1892
## Arts and Crafts Architect

One of Leicester's most successful architects, Isaac Barradale, was regarded by his own prodigy, Ernest Gimson, as one of the finest architects of the Arts and Crafts movement in the country. His work can still be seen in many areas of Leicester and Leicestershire.

Barradale was articled to William Flint and set up his own business in Leicester, based in the Greyfriars area, in 1870. He had an important influence on the appearnace of Leicester, especially in the area of London Road and Stoneygate, where he made popular the English Domestic Revival style for housing. Fine examples of this powerful style can be seen in buildings such as No. 3 Greyfriars, the 'Stoneygate' house, St George's Chambers, the Cottage Homes in Countesthorpe, and Fenwick's department store in Market Street. The building opposite Fenwick's was also designed by Barradale and was built as a hotel.

Two outstanding houses by Barradale are in Stanley Road in Stoneygate. The Croft was formerly known as 'Elmhurst'. This house and the adjacent one, 'Carisbrooke', are almost identical and were built for two sisters by their doting father. The magnificence of the houses is created by the powerful eaves, towering chimney stacks and splendid balconies – very typical of Barradales 'Leicester' style. A more unusual example is his building in Wharf Street, which for many years was known as Leif's pawnshop.

He was buried in Welford Road cemetery, where his wife Elizabeth and his two children, one of whom died in infancy and the other aged eighteen years, are also buried.

'Croft' and 'Carisbrooke': two houses on a grand scale by Leicester architect Isaac Barradale.

## 41. MARY ROYCE, 1845–1892
## Educational Reformer and Leicester's First Woman Doctor

Mary's lifetime commitment was to foster the spiritual, educational and social needs of the people of Leicester. Her institute, which began life as a Sunday school in Sanvey Gate in 1868, is still operating today, adhering to the same principles.

Responding to the needs of the children who she would meet on Sundays, Mary developed weekday evening classes where she would teach basic reading, writing and arithmetic. These expanded in time to include the study of chemistry, anatomy, geography, afrench, Latin and Greek.

She also organised outings for her young people to the Charnwood Forest where, as well as studying the natural world, they would take part in organised sporting activities. The 'school' outgrew its original premises and moved to larger rooms in Slater Street School. Later, she organised Saturday evening 'social meetings', where the young men could bring their wives and girlfriends.

Mary was one of the first women in England to train as a doctor after the medical degree was opened to women in 1875. She studied, mainly in London, for thirteen years before qualifying at the age of forty-four. Although heavily committed to her training, she returned to Leicester every weekend to continue her classes and social events.

She later purchased properties in Churchgate to provide her institute with a permanent home, running her medical practice from adjacent rooms.

She died in 1892 after contracting an illness she caught while tending a woman in the Leicester Workhouse.

The Royce Institute continues her work, and since 1969 has been based in its own building in Leicester's Crane Street.

The Royce Institute.

## 42. STOCKDALE HARRISON, 1846–1914
**Architect**

Stockdale Harrison trained in Leicester under James Bird, and then moved to London where he worked with George Somers Clarke. He returned to Leicester in 1870 and set up a private practice in Hotel Street, moving to No. 7 St Martin's in 1876.

He became an associate of the Royal Institute of British Architects (RIBA) and a fellow in 1890. Locally, he served as president of the Leicestershire and Rutland Society of Architects.

Two of his sons joined the practice. James Stockdale Harrison (1874–1952) was articled to his father from 1892, and became an assistant after passing his qualifying examinations in 1898, working as the company's business manager. Shirley Harrison (1876–1961) joined the company in 1904, and from that time the practice was known as Stockdale Harrison & Sons.

Stockdale Harrison initially designed in the Gothic Revival style, which he continued to use for churches. By the 1880s, he developed his own version of what is now described as the Domestic or Vernacular Revival style. Examples of the company's work are the lodge at Spinney Hill Park, Hastings House, Stoughton Drive South, and the Abbey Pumping Station. His last work was St Guthlac's church, South Knighton, constructed in 1912.

From 1904, many of the Arts and Crafts style works by the company were designed by Shirley Harrison who, with H. H. Thompson, also designed De Montfort Hall (1913) and the Usher Hall in Edinburgh.

Shirley Harrison's De Montfort Hall (1913), pictured in its centennial season.

## 43. HENRY CURRY, 1850–(?)
### Founder of Curry's Retail Stores, Now Dixons and PC World

As an apprentice working the engine house of the Corah textile factory in St Margaret's, the young Henry Curry learned how to weld and machine steel tubing. It is said that he began building rudimentary bicycles during the long night shifts at Corah's. He left in 1884 to start his own manufacturing business, based in the garden shed in his family's home at No. 40 Painter Street, near to the Corah works, which is now part of the Leicester College campus.

His first retail store was in Leicester's Haymarket, near to the Clock Tower. It opened in 1890, and as his business developed he moved on two separate occasions to larger premises in Belgrave Gate.

In 1897, his sons joined him and the company became known as H. Curry & Sons. The business was floated on the Stock Exchange in 1923, by which time Curry had begun selling toys and electrical equipment, such as wireless sets and gramophones. The company stopped making bicycles in 1932 when their Leicester factory closed, but they continued to sell bicycles bearing their Hercules brand name until the 1960s.

Currys was taken over by Dixons in 1984, and various mergers and changes in brand identities followed, including changing the names of stores from Dixons to Currys Digital. Although most of the original Currys shops have now closed, the family name has survived as the present branding of some 500 retail outlets in the overall group and their online trading presence.

There is still a Currys store in Leicester, in the Haymarket Centre, near to the site of Henry's original shop.

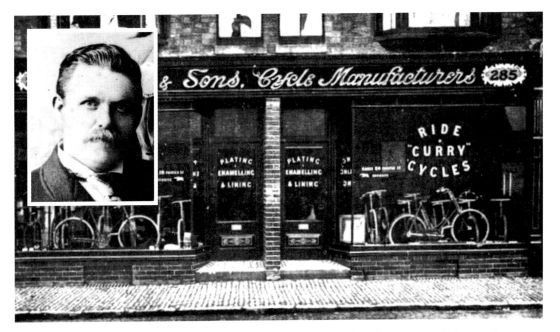

The third shop belonging to Henry Curry (who is pictured in the inset), in Belgrave Gate, Leicester, c. 1895.

Agnes Archer Evans, 1848–1924, and the commemorative plaque dedicated to her, which lies outside her former home at No. 6 St Martins.

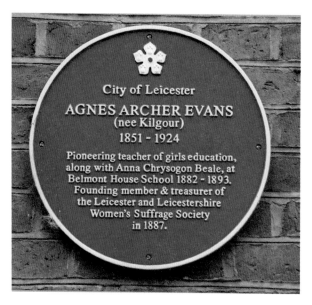

## 44. AGNES ARCHER EVANS, 1851–1924
### Headmistress, Reformer, Women's Suffrage Campaigner

Agnes was born on the island of Van Diemen's Land on her father's estate. He was a Scottish physician who worked as a medical officer on the island before the family eventually returned to England.

She became a teacher and moved to Leicester's Belmont House School in De Montfort Street, now the Belmont Hotel.

In July 1895, Agnes married prosperous Leicester corn miller, William Evans, in Cheltenham. They lived at No. 6 St Martin's, Leicester, opposite St Martin's church, now Leicester Cathedral, with her husband's two children from his previous marriage.

Though she did not return to teaching, Agnes Archer Evans made many significant contributions to the life of people in Leicester. She served on the Leicester School Board, the Council of Vaughan College, and the University College when it was established, and involved herself in the work of the Womens' Suffrage Movement. Her husband died in 1921. Agnes then moved back to Cheltenham, where she died three years later.

## 45. SIR JOSEPH HERBERT MARSHALL, 1851–1918
### Concert Impressario

Sir Joseph Herbert Marshall greatly enriched the
musical life of Leicester when, in 1886, he founded
the Leicester Philharmonic Society.

He was born in Zouch Mills near Hathern, and first
took public office when elected to the town council in
1888, representing East St Mary's Ward. He served as
lord mayor in 1896, and became an alderman in 1909,
and a magistrate for the borough and county in 1892.

He was knighted by King Edward VII in 1905.
While lord mayor of Leicester, he commemorated
the Diamond Jubilee of Queen Victoria by raising
£10,000 for the Jubilee Endowment Fund of the
Leicester Royal Infirmary.

He died at his home, Ratcliffe Lodge, in 1918 and
was buried at Welford Road Cemetery.

Joseph Herbert Marshall, Lord Mayor
in 1896.

## 46. TOM BARCLAY, 1852–1933
### Working Class Leader and Pioneer

Born of Irish immigrant parents, Tom Barclay grew up in poverty. He was working at the age
of eight in a rope works earning 1s 6d a week, and spent his entire life in low-paid employ-
ment in hosiery factories and dye works in Leicester. He never attended a school but had a
desire to learn. By attending classes run by Revd David Vaughan, he learned to read and later
wrote his autobiography, *Memories and Melodies: The Autobiography of a Bottle Washer*.

Throughout his long life, Tom was involved in the struggle of the working classes as an
active member of the Secular Society where he spoke regularly, and through corresponding
with leading intellectuals, including George Bernard Shaw.

He continued to absorb knowledge by studying an amazing array of subjects from geology
to poetry, learning foreign languages and engaging in political debate and social agitation.

In later life he began to investigate his Irish cultural roots and learned Gaelic. He died on
New Year's Day in 1933.

## 47. HENRY WALKER
### Founder of Walker's Crisps

Eleven million bags of potato crisps are produced in Leicester every day using in the region
of 800 tons of potatoes. The very first Leicester potato crisp was made at a butcher's shop
in Cheapside by Henry Walker in 1948. He had moved to Leicester in the 1880s and
purchased an established butcher's in the High Street. His business prospered, and in 1912
he moved to larger premises, from which Walkers the butcher's is still trading today.

Henry Walker's original Cheapside Pie Shop, refurbished in 2013.

Rationing after the Second World War meant meat remained in short supply. It was said that Walkers would have completely sold out of products by mid-morning with their production areas running at half capacity. Henry and his son searched for alternatives to maintain his business and to keep his factory staff employed.

Walker's managing director R. E. Gerrard first proposed selling ice cream, but hygiene and health legislation did not allow meat and dairy products to be processed in the same factory area or by the same workers. Consequently, Gerrard looked to the potatoes, which were not rationed. Some reports suggest that customers accepted Walker's first crisps, cut thickly and deep fat fried, as a reasonable alternative in terms of texture and colour to the poor meat cuts they had become used to during the war years.

The first crisps were cut by hand and fried in a fish and chip deep fat fryer. Gerrard cooked the first batch himself. They were an immediate success and the company soon set up a production line specifically for crisps in the upper storey of their Oxford Street factory. They continued to experiment, and in 1954 the first flavoured crisp was produced – cheese and onion.

Leicester's Gary Lineker, whose family have been prominent on Leicester Market, just yards from the Walkers shop, has been the 'brand image' of Walkers crisps for several years, and two of the company's television advertisements have been filmed in the city.

## 48. CHARLES BENNION, 1857–1929
### Businessman and Philanthropist

For over 80 years people, from Leicester and beyond have enjoyed the freedom to roam across the 850 acres of the former Grey estate, now known as Bradgate Park. It is an area of great

natural beauty and is a major element of the wider natural environment of Leicestershire. It was the gift to the city of Charles Bennion, and he made it just months before his death.

The son of a farmer, Charles Bennion was fascinated by the new technologies of his age such as the steam engine, and could see that they had the potential to revolutionise agriculture, transport and manufacturing.

His technical career began in the railway works of the London and North Western Railway in Crewe, but with an impatience to learn, he chose to widen his experience of life by working as a ship's engineer, thus being able to visit many different countries and cultures.

When he returned to England, he became involved in shoe machinery manufacture and by 1890 had settled in Leicester, where he established Pearson and Bennion Ltd, in partnership with Leeds businessman Marshall Pearson. This company formed the basis for the massive British United Shoe Machinery Company (BUSMC), which, with Bennion as its managing director from 1899 until his death in 1929, was the major employer and manufacturer in the shoe machinery trade in the region. During the Second World War, the company turned to war production, producing, amongst many items, the technically demanding wheel housing for the Rolls Royce Merlin engines used on Spitfires and Lancaster bombers for the Royal Air Force. Until the 1970s, BUSMC was the largest employer in Leicester.

The company collapsed in 2000, and the employees consequently discovered that the preceding financial crisis had commandeered their pension fund. In 2007, the government announced some partial reparations for the many that had been affected.

A plaque set in local granite and commemorating Charles Bennion's generosity can be found in Bradgate Park. It reads:

> In grateful remembrance of Charles Bennion of Thurnby of this county who in 1928 with the helpful concurrence of the heirs of the Greys of Groby purchased from them this park of Bradgate and presented it in trust for the city and county of Leicester that for all time it might be preserved in its natural state for the quiet enjoyment of the people of Leicestershire. His true memorial lies around.

## 49. ARTHUR WAKERLEY, 1862–1931
**Architect and Philanthropist**

The Wakerley family had lived in Leicestershire since the 1500s, first in Twyford and then in Melton Mowbray, where Wakerley was born on 15 May 1862. He moved to Leicester when he was articled to architect John Bird.

While working under Bird, Wakerley was tasked with surveying streets and buildings in Evington. He saw the potential to develop the North Evington area and, later, when in business in his own right, he purchased land in the area on which stood redundant brickworks. He began developing the area as a self-contained community with its own infrastructure – places of employment and amenities as well as housing, but as an advocate of temperance, he saw no place for licensed premises. He was later to live in North Evington, on Gwendolen Road in a residence called Crown Hills, which he designed himself.

An extremely active man, Wakerley was a member of the council, alderman, mayor (in 1897) and JP. He was an enthusiastic Wesleyan lay preacher, a temperance worker, an

amateur archaeologist and a poet. His philanthropic activities included raising money for the building of the Wycliffe Cottage Homes for the Blind, and for the support of the families and men who suffered as a result of the Whitwick Colliery Disaster.

He immortalised his four daughters – Gwendolen, Constance, Dorothy and Margaret – by naming roads after them.

## 50. ALICE HAWKINS, 1863–1946
### Leader of the Suffrage Movement in Leicester

Alice Hawkins was jailed five times for campaigning for the right of women to have a vote, and was buried in an unmarked pauper's grave. Today she is commemorated as a woman who fought unceasingly for justice and for the inspiration she gave to many others.

Alice lived most of her life in Leicester, and for almost all her working life, was employed as a shoe machinist at Equity Shoes. The company, being an early form of workers' co-operative, was supportive of her campaigning activities. She was one of nine children, and had six children herself.

She joined the newly formed Independent Labour Party in 1894. In 1907, on the day of the state opening of parliament, Alice was arrested for disorderly conduct at the gates of the House of Commons. She and twenty-eight other women were sentenced to fourteen days imprisonment in Holloway Prison. Alice was imprisoned again in 1909 after trying to force her way into a public meeting in Leicester, where Winston Churchill was speaking and in 1911, for breaking windows at the Home Office.

A friendship was formed with Sylvia Pankhurst who visited Leicester on several occasions to support Alice's work, including the formation of a local branch of the Women's Social and Political Union, an organisation created by the Pankhursts. Sylvia Pankhurst returned to the town in the summer of 1907 to visit Alice's fellow workers at Equity Shoes.

Alice was able to present her case for women's rights to David Lloyd George in 1912, but the outbreak of First World War brought the suffragettes' campaign to an abrupt conclusion.

## 51. ERNEST GIMSON, 1864–1919
### Designer and Architect

The architectural style of Ernest Gimson has been described as 'solid and lasting as the pyramids ... yet gracious and homelike', and some excellent examples of his craft have survived in Leicester, including 'Inglewood' in the Stoneygate area, intended as his own home though he was never to live in it.

Gimson was the son of the engineer and iron founder Josiah Gimson. He studied at the Leicester School of Art alongside George Percy Bankart, and was articled to the Leicester Arts and Crafts architect Isaac Barradale. In 1885, he won a national prize for furniture design.

It was a visit to Leicester's Secular Hall by William Morris that gave Gimson a new direction for his career. Morris introduced him to the London architect John Dando Sedding, for whom he then worked until 1888.

After travelling and studying for a further two years, he founded a company in Bloomsbury to produce 'furniture of good design and good workmanship', but the project failed due to

*Top left*: Charles Bennion, 1857–1929. *Top Right*: Arthur Wakerley, Lord Mayor of Leicester in 1897. *Bottom right*: Ernest Gimson at Sapperton. *Bottom left*: Colin McCalpin, 1870–1942. *Centre*: Harry Hardy Peach, 1874–1936.

lack of investment capital. In 1893, he moved to Gloucestershire, setting up a workshop with Ernest and Sidney Barnsley, first at Pinbury Park and later in nearby Cirencester. They moved to Sapperton in 1902, but the Barnsleys left four years later after a violent disagreement.

Gimson continued at Sapperton, working on his own, designing and producing distinctive metalwork and furniture for discerning and wealthy customers. He died there in 1919, aged just fifty-four.

## 52. COLIN MCCALPIN, 1870–1942
### Musician and Composer

A talented musician, whose work has often been overlooked, Colin McCalpin was born at No. 67 Sparkenhoe Street in the Highfields area of Leicester. He attended Wellingborough School where he published his first composition, from an opera called *Robin Hood*, at the age of fifteen. He was admitted to the Royal Academy of Music in the following year.

He was a skilled organist and the composer of five operas, a cantata, many songs, and one very difficult piece for piano – *Fantastic Dance*. His opera *King Arthur* received its premier in 1896 and was performed by the Leicester Philharmonic Society in 1897. His cantata *Prince of Peace* was also performed by the Leicester Philharmonic Society at Covent Garden.

McCalpin died at his home in Dorking, Surrey. He was married to Susette Peach, and they had one son. McCalpin's life and work was neglected for many years until research by Leicester musicologist and teacher David Fisher in 1989.

## 53. HARRY HARDY PEACH, 1874–1936

A talented and farsighted man, Harry Peach combined entrepreneurial business ability with a desire to help and support the less privileged in truly practical ways. His family roots were in Nottinghamshire, but he was born in Canada, arriving in the Oadby area of Leicester at an early age when his family decided to return to England. He attended Wyggeston Boys' School and then Oakham School.

Initially, he worked as an estate agent, but later established a bookshop at No. 37 Belvoir Street, specialising in manuscripts and early printed books.

He and his first wife, May, were closely involved in local politics and social reform, and both were members of the Independent Labour Party. Harry assisted in an exhibition on the sweated trades as part of Ramsey McDonald's 1906 election campaign in Leicester.

He met Benjamin Fletcher, the principal of the Leicester School of Art, who introduced him to the Arts and Crafts movement, and in particular the work of William Morris and William Lethaby. Together, Peach and Fletcher formed their first enterprise, producing cane furniture.

They established Dryad Furniture in 1907 in Belvoir Street. Within four years, their workforce had grown to fifty, and in 1912 they moved to larger premises in St Nicholas Street, and also set up a further company, Dryad Metal Works.

Peach promoted the use of craft work as part of occupational therapy rehabilitation for wounded and ex-servicemen during the First World War and in 1918, set up Dryad Handicrafts to supply schools with craft materials. When he died, Dryad Handicrafts had become the largest supplier of craft materials and the largest publisher of craft publications in the world.

Politically and socially aware, literate and clear-thinking, Harry Peach made a profound difference to the quality of life of many tens of thousands of people.

## 54. RAMSAY MACDONALD, 1866–1937
### First Labour Prime Minister

The illegitimate son of a farm labourer and a housemaid from Lossiemouth on the Moray Firth, Ramsay MacDonald's association with Leicester began formally in 1899 when he was nominated to stand as one of the two MPs representing the town. In that year, influenced by the manner in which organisations representing or supporting the working classes in Leicester worked together – including the Independent Labour Party, the Leicester Trades Council and the Boot and Shoe Union – MacDonald toured the country with his fellow Labour activist Freddy Richards, promoting the concept of working alliances between the Labour Party and such organisations.

MacDonald's political beliefs were formed while he was working as an assistant to a clergyman who had established a guild for boys and young men. Here he was introduced to the highly radical Democratic Federation, which became the Social Democratic Federation, the first organised socialist political party.

In Leicester, he and his wife formed a close friendship with Clara Collet, who was teaching at Wyggeston Girls' School in Leicester. Collet was a powerful ally of the working classes, who later as a civil servant in the Board of Trade, saw through many reforms, and was a strong influence on MacDonald.

An election meeting in the market place, *c.* 1900, with Ramsay MacDonald on the platform.

He was elected the MP for Leicester in 1906, the year that the Labour Representation Committee became the Labour Party. He was chairman of the LRC and became chairman of the Labour Party in 1911.

At the outbreak of the First World War, MacDonald lost popular support and public confidence because of his anti-war stance, being publicly accused of being a traitor to his country and a coward. He returned to Parliament in 1922, when Labour replaced the Liberals as the second largest political party in Britain.

His first government as prime minister lasted just nine months in 1924. It was formed with Liberal support, with a cabinet of many men from working class origins. In the shadow of the Great Depression, Labour won the general election of 1929 and in Leicester, MacDonald was granted the Freedom of the City, despite opposition from local Conservatives. Two years later, he was leading a coalition government, having resigned after failing to win approval for drastic public spending cuts. For the second time in his career, he faced the rejection of his former colleagues, branded a traitor to his political ideals.

Due to ill health he stood down in 1935, but remained in the cabinet until 1937 when he retired from politics. He was advised to undertake a cruise to assist his recovery. He died on board the liner *Reina del Pacifico* at sea on 9 November 1927, and was buried alongside his wife in his native Morayshire.

## 55. REVD JAMES WENT, 1845–1936
### First Headmaster of Wyggeston Boys' School

Born in Worcester, James Went moved to Leicester in 1877 to become the most famous Headmaster in the history of the Wyggeston Boys' School, retiring in 1920 after forty-three years in the post. He was involved in many local organisations, and was the president of the Incorporated Association of Headmasters in 1905, serving on its governing council until his retirement in 1920. Went was educated at Worcester Cathedral School and Trinity College Dublin. He was ordained and served at churches in his home city. His first teaching appointment was as assistant classical master at Nottingham High School (1869–72), followed by second master at Bradford Grammar School (1872–77).

He remained in the Leicester area for the rest of his life, serving as an Honorary Canon of Leicester Cathedral. His publications included *Old School Days: A Short Account of William Wyggeston's Foundation and of Queen Elizabeth's Grammar* and *A Latin Exercise Book Facillima*, published in 1897.

His contribution to education was commemorated in the James Went Building, now demolished, which was part of the former Leicester Polytechnic's Newarke campus. In 2009, a major new extension to the Wyggeston and Queen Elizabeth I College was named after this much-admired headmaster. The building, designed by Pick Everard, has subsequently won several major awards.

## 56. JOSEPH CAREY MERRICK, 1862–1890

The sad but no less inspiring life of Joseph Carey Merrick came to the attention of the wider public with the release of the film *The Elephant Man* in 1980, in which John Hurt

took the role of Merrick, and the book by Michael Howell and Peter Ford on which the film was based.

It is easy to see Merrick's short life as tragic. His disability could not, and cannot, be overlooked or understated. In addition, as a boy he mourned the death of his mother, and then faced persecution, abuse and finally rejection by his own father. Yet his own account of his life, written at the request of the manager of a novelty emporium in London where Joseph was 'appearing', is not angry or despairing in tone, but incredibly honest and objective.

Joseph was born at No. 50 Lee Street in the Wharf Street area of Leicester. His parents both worked in the textile trade. It was a very poor area, with families constantly struggling to keep above the breadline. His disfigurement became apparent when he was about five, but until the age of twelve and the death of his mother, he attended the local school and received a good basic education.

When his father married his landlady, Joseph became a stranger in his own home. He was befriended by his father's brother, who was a hairdresser in Churchgate, almost opposite St Margaret's church. His stepmother sent him out to work, rolling cigars at Freemans, the cigar manufacturers in nearby Hill Street. He held onto this employment for two years until his hands became too clumsy for the work. His father then sent him out as a hawker, selling goods, street to street, but his growing deformity meant people were either fearful of, or repulsed by the young lad on their doorstep. One evening, after returning home having made no sales, his father beat him. Joseph chose to admit himself to the workhouse in Sparkenhoe Street at the age of seventeen.

While an inmate, he underwent an operation at the Leicester Royal Infirmary to remove some of his facial disfigurement. He also released himself from the workhouse for a short period but, unable to find work, was readmitted.

Merrick himself initiated the association with showmen who enabled his release. He contacted Sam Torr, who owned the Gladstone Vaults in Wharf Street, close to where Merrick was born and had lived. Torr and his business colleagues agreed to Joseph's proposal that he appeared on stage as an 'attraction'.

There is only sparse detail available of Joseph's time with Torr in Leicester and the East Midlands, with showman Tom Norman in London, and his sad tour of Belgium where he was robbed and left abandoned. More is known about the period after he was taken in to the London Hospital by the surgeon Sir Frederick Treves where Merrick remained until his death in 1890 at the age of twenty-seven.

In his early years, Merrick demonstrated incredible tenacity and courage in maintaining control of his own destiny in a world where disability was ignored, shunned or regarded as a money-making opportunity. He chose to enter – and leave – the workhouse, to contact showman Sam Torr, to move to London and to travel to Belgium. In his last years as a patient – and friend – of Frederick Treves, he was befriended by many people from different walks of life who showed him much kindness, and respected him for his intelligence and courage.

A plaque with the words 'a true model of bravery and dignity for all peoples, of all generations' was unveiled in 2004 at the Gladstone Vaults. After the building was demolished, the plaque was relocated to Moat Community College, which stands on the site of the former workhouse.

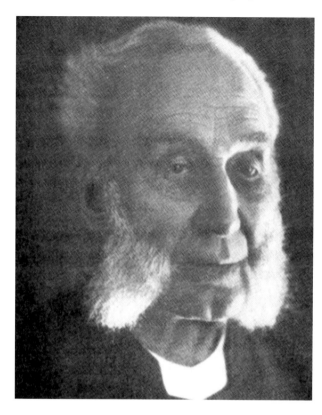

*Left*: The Revd James Went,
1878–1920.

*Below*: Wharf Street and the
Hippodrome Theatre in 1951.

## 57. GEORGE PERCY BANKART, 1866–1929
## Artist, Arts and Crafts Movement

Bankart studied at the School of Art in Leicester with Ernest Gimson. He taught at the Bromsgrove School of Handicraft, and later developed his concepts and ideas on style in his influential *The Art of the Plasterer*, which he wrote in 1908 and called for a revival in basic traditional techniques.

As a practicing plaster worker, it is said that he worked on some of the ceilings of the Victoria and Albert Museum in London, several houses and buildings in Leicester, such as the National Westminster Bank and the Freemasons' Hall, and various other important buildings often linked nationally to the Arts and Crafts movement. The lead font in St Alban's church, Harrison Road in Leicester, is also by him.

## 58. BENJAMIN JOHN FLETCHER, 1868–1951
## Pioneering Head of Leicester School of Art

Fletcher was born in Ironbridge in Shropshire, where his father was an iron moulder at the famous Coalbrookdale Iron Company. Benjamin joined his father at the company at the age of eleven, working as an errand boy.

By the age of seventeen, he was teaching part-time at the Coalbrookdale School of Art under Augustus Spencer, who in 1888 was appointed headmaster of the Leicester School of Art at its premises in New Walk, now part of the museum. Spencer took Fletcher with him as his deputy. The partnership was successful in building the reputation of the school, and in 1899 it moved into the newly constructed first phase of the Hawthorn Building in the Newarke.

In 1900, Fletcher succeeded Spencer as headmaster and began a programme of innovation and expansion. In 1901 the School Board adopted a new syllabus for drawing, written by Fletcher, to be used in all Leicester schools from kindergarten to upper schools. Already aware of the far more advanced approaches to both general art and design and to relating design to industry on the Continent, he quickly made a number of study visits, particularly to Germany and Austria, and he also followed up his existing contacts with those involved in the Arts and Crafts movement, including Ernest Gimson.

In 1902, Fletcher married Margaret Joan Reynolds. They set up home at The Red House, No. 281 Fosse Road South, Leicester. His influence in artistic and education circles continued to grow as he pursued both innovation and experimentation.

He was responsible for the re-establishment of cane furniture production techniques that had almost completely died out in Britain, which was taken up by his friend and associate Harry Hardy Peach through his Dryad companies, and also by others such as Angrave Cane Furniture Ltd. Leicester quickly became a major centre for cane and willow furniture.

Fletcher joined Peach and other leading art and design figures in submitting a document to the government and the director of the Victoria and Albert Museum, arguing for action to be taken to link design with industry. It was quickly adopted, and in 1915, the Design and Industries Association was set up with Fletcher and Peach among its founder members.

In 1920, Fletcher left Leicester to become headmaster of the Birmingham Municipal School of Art. He retired in 1934 to Sapperton near Cirencester, which had been the centre

of the Cotswolds' Arts and Crafts movement since the days of Ernest Gimson, where he and his wife lived in Gimson's former workshops and showroom. He was buried at Sapperton.

His influence on education and craft design is commemorated in Leicester by the Fletcher Building on the De Montfort University campus, close to the Hawthorn Building where many of his ideas and concepts were formed and took shape.

## 59. DR ARTHUR NICHOLAS COLAHAN, 1884–1952
## Popular Music Composer, Psychiatrist and Neurologist

Colahan was perhaps more often recognised by the inmates of Leicester's Welford Road prison than by the millions who purchased his songs, either in sheet music form or as recordings.

He was a quiet man who was often homesick for his beloved Galway Bay in Ireland. These feelings led him to write one of the most popular songs of all time, and the bestselling song of 1953. However, by the time his music had achieved popularity, he had died and had been buried in an unmarked grave in his Irish birthplace.

He was born in Enniskillen on 12 August 1884, the eldest son of Nicholas and Lizzie Colahan. He was a boarder at Mungret College in Limerick, and then enrolled at University College Dublin in 1900, where he gained an arts degree. He took up medicine and graduated from Queen's College, Galway, in 1913. He was a member of the Literary and Debating Society at his college and took part in many college plays, where his skill as a composer and songwriter was first revealed.

He began a medical career in the County Infirmary in Galway. When the First World War broke out, Colahan enlisted in the British Army's Medical Corps and served in India. There he was badly affected by mustard gas. After the war, he settled in Leicester where he worked as a neurological specialist in the police and prison services. His hobby was music, and he wrote songs with fine memorable melodies including *Until Gods Day*, *Cade Ring*, *Asthoreen Bawn*, *Macushla Mine*, *The Kylemore Pass* and the beautiful *Galway Bay*.

*Galway Bay* was written in memory of one of his brothers, who drowned in the bay. It is a song about the grief of exile. It was included in the 1952 film *The Quiet Man* starring John Wayne and Maureen O'Hara, which told the story of a disgraced American boxer retiring to Ireland where he finds true love. However, Colahan is not included in the film's credits.

Dr Colahan died at his Leicester home at No. 9 Prebend Street off London Road on 15 September 1952, and his remains were moved to Galway for burial in the family grave. Family disputes, particularly with relatives of his estranged wife, meant that his closest relatives were not present at his funeral and interment. Today, there is no record of his name on the Celtic Cross in Galway Cemetery that marks the last resting place of the man of whom it was said 'money didn't interest him, Glory didn't interest him. He was very gentle and very humble'.

## 60. ROBERT FLEMING RATTRAY, 1886–1967
## Unitarian Pastor, Educationalist, Principal, University College

Robert Rattray had a very broad education before moving to Leicester in 1917 to become the pastor of the Unitarian Great Meeting in Leicester. He was educated at Glasgow University, his home town, Manchester College, Oxford, Germany, and Harvard, where he gained his PhD.

*Top left*: Benjamin John Fletcher, 1868–1951. *Top right*: Dr Arthur Colahan, 1884–1952, in a portrait at the time of his graduation. *Bottom right*: An edition of Colahan's famous *Galway Bay* commemorating Bing Crosby's recording. *Bottom left*: Robert Fleming Rattray, 1886–1967.

He was a strong supporter of both the adult education movement and the plans to establish a university in Leicester. In May 1921, he became the first principal of the Leicester, Leicestershire and Rutland College, which became the University College. His respected academic record and teaching experience at the Workers' Educational Association in Leicester made him a popular choice for the role.

He remained at Leicester as principal of the University College until 1931, when he moved to Cambridge to become pastor of the Unitarian Memorial chapel where he lived out his retirement years.

## 61. FREDERICK LEVI ATTENBOROUGH, 1887–1973
### Principal, University College, Leicester

Born in Nottinghamshire, Frederick Attenborough attended Emmanuel College, Cambridge, in 1915, and in 1919 became a Fellow of Emmanuel, specialising in Anglo-Saxon studies. His academic reputation was established by his *The Laws of the Earliest English Kings*, published in 1922.

In 1932, he moved to Leicester and became the second principal of the University College after Robert Rattray. Under Attenborough's leadership, the college developed from a small and poorly-funded local institution to a nationally-recognised centre of academic excellence, preparing the way for the Royal Charter of 1957, when the college became the University of Leicester.

Attenborough was a strong supporter of Leicester's museums service, especially in the immediate post-war years. He and his wife were very active in local and national humanitarian and cultural activities. They were closely involved in the protection of human rights and for the care of refugees from Europe arriving in Leicester from Nazi Germany and the Spanish Civil War in 1930s. They 'adopted' two Jewish girls under the 'Kindertransport' programme. They were also strong supporters of the Little Theatre in Leicester, where their son Richard made his first stage appearances.

Attenborough was a keen photographer and provided many of the photographs to illustrate W. G. Hoskins' pioneering books on landscape and architecture, including his groundbreaking *Leicestershire: An Illustrated Essay on the History of the Landscape* and *The Making of the English Landscape*.

## 62. LAWRENCE WRIGHT AKA HORATIO NICHOLLS, 1888–1964
### Music Publisher and Composer of Popular Music

By the age of ten, Lawrence Wright was already a familiar figure at Leicester Market, working on his father's music stall selling sheet music and musical instruments. He set up his own stall on the market when he was sixteen.

He was born above his father's music shop at No. 23 Upper Conduit Street off Leicester's London Road, and from an early age was able to play a number of instruments.

While still in his teens, he rented premises three doors away from the family home, where he set up the Wright Music Company. Its first published hit tune 'Don't go down the mine, Daddy' by William Geddes and Robert Donnelly came just four years later. By 1912, he had

moved his business to Denmark Street in London's Tin Pan Alley, and he was later to open shops in many seaside towns, including Blackpool, Llandudno and Douglas, Isle of Man.

Under the pseudonym of Horatio Nicholls, Wright began to write his own songs. Of the more than 600 tunes he wrote during his career, the most famous is 'Among My Souvenirs', which has been recorded by many artists, including Hoagy Carmichael, Bing Crosby, Frank Sinatra, and Connie Francis.

Lawrence Wright also launched *Melody Maker* in 1926, staged an annual musical production in Blackpool for over thirty years and was presented with an Ivor Novello Award in 1962 for his outstanding service to British popular and light music.

## 63. JENNIE FLETCHER, 1890–1968
Freestyle Olympic Swimmer

Jennie Fletcher's family owned a fish shop in the Belgrave area. She attended Mellor Road Primary School, but as one of eleven children, she had to go out to work in a textile factory from a young age, and could only focus on her swimming after a twelve-hour working day, six days a week.

In the first decade of the twentieth century, Jennie became Britain's leading female amateur swimmer, breaking numerous records. In 1906, she became Leicester's all-round swimming champion, and at one event at the Cossington Street baths, 2,000 spectators watched as she became the new English 100 yards swimming champion. She remained an amateur, winning six ASA 100 yards freestyle titles between 1906 and 1912, and in 1909 set a world record for the distance. In all, she won twenty major titles and set eleven world records.

Jennie became a household name, attracting large crowds and was selected for the 1912 Summer Olympics held in Stockholm. Here she won bronze in the 100 metres freestyle and a gold medal in the 4x100 metre relay. She appeared in an expensive, one-piece silk swimming costume, she and her British teammates representing a new kind of modernity: the lightweight and revealing costumes were designed on the principles of competition rather than modesty.

She retired from swimming in 1913 and married a local man, Henry Hyslop. They emigrated to Ontario, Canada where they had a daughter and five sons. She died in 1968, at the age of seventy-eight, and became a member of the International Swimming Hall of Fame in Florida in 1971. Her daughter Betty Smith recalls that Jennie was always spoke modestly about her sporting successes: 'She was so modest and if her career was discussed, she'd say, "Oh, that was a long time ago and I did it because I just loved to swim."'

## 64. MEYRICK EDWARD CLIFTON JAMES, 1898–1963
Actor and Soldier – Montgomery's Double In Operation Copperhead (1944)

One of the many remarkable stories of undercover operations during the Second World War involves an Australian actor who, while appearing on stage in Leicester, was selected to impersonate Field Marshal Bernard Montgomery.

Clifton James was born in Perth, Australia, and served in the First World War. He was badly gassed during front line operations. After the conflict, he became an actor

*Top left*: Frederick Levi Attenborough, 1887–1973. *Top right*: Lawrence Wright, 1888–1964. *Bottom right*: Jennie Fletcher, 1890–1968. *Bottom left*: Meyrick Edward Clifton-James as Field Marshal Montgomery.

A compilation song book published by Lawrence Wright Music.

and entertainer working in English music halls for promoters such as the infamous Fred Karno. At the start of the Second World War, Clifton James offered his services to the British Military as an entertainer, hoping that he would be accepted into ENSA, but instead was commissioned into the Royal Army Pay Corp and stationed in Leicester.

In the build-up to D-Day in 1944, Clifton James' resemblance to Montgomery was noticed by an Army Lt-Colonel who saw his photograph in a newspaper review. The actor was playing in a satirical review. At the end of one performance, having lost the hat he would have normally worn for the curtain call, James put on an Army beret. When he walked on stage, the audience stood up and cheered, believing him to be Field Marshal Montgomery. Being an actor, he played to the audience in accepting the applause.

He was contacted by David Niven, the English actor who at that time was working for the British Army's film unit, and was instructed to come to London on the pretext of making a film.

A plan was drawn up, code-named Operation Copperhead, and was intended to deceive German intelligence into believing that an Allied invasion of Southern France would precede any northern invasion.

Clifton James was assigned to Montgomery's staff to learn his speech and mannerisms. Clifton James had lost his right-hand middle finger in the First World War, and so a prosthetic finger was made.

On 25 May 1944, he flew to Gibralta on Churchill's private aircraft and during a reception, acting as Montgomery, made hints of a 'Plan 303' to invade Southern France, which were reported back to German intelligence. He then went on to Algiers, making appearances with the Allied commander of the Mediterranean theatre before being flown secretly to Cairo, and finally back to England and Leicester.

He continued in the Pay Corps until the end of the war, received no official recognition for his services, and inevitably had to lie about the his 'missing' five weeks. In 1954, he published a book about his adventure that became the basis for a film, *I Was Monty's Double*, starring John Mills and Cecil Parker, in which James played himself and Montgomery.

# 1900–Present

## 65. CHARLES PERCY SNOW, BARON SNOW OF LEICESTER, 1905–1980
### Novelist and Physicist

The son of a Leicester shoe factory clerk and part-time church organist, C. P. Snow was educated at the Leicestershire and Rutland College (now the University of Leicester) where he read chemistry and graduated with an MA in physics. He gained his PhD at Cambridge and in 1930, became a fellow of Christ's College.

He joined the Civil Service, in which he held several senior posts including the technical director of the Ministry of Labour from 1940 to 1944, and civil service commissioner from 1945 to 1960. Moving into politics, he became parliamentary secretary in the House of Lords to the Minister of Technology from 1964 to 1966, under the Labour administration of Sir Harold Wilson.

His sequence of novels began with *Strangers and Brothers* (1940). Other books include *Corridors of Power* (1964) and *The Sleep of Reason* (1968). His published texts include sixteen novels and nine works of non-fiction. He was knighted in 1957 and was made a life peer, as Baron Snow of the City of Leicester, in 1964.

An artist's impression of Conrad Smigelski's plans for redesigning Leicester's Gallowtree Gate.

## 66. WILLIAM GEORGE HOSKINS, 1908–1992
## Pioneer in the Academic Study of English Local History

Born in Exeter, the son of a baker, Hoskins' greatest contribution to the study of history was in the field of landscape history. He demonstrated the impact of human activity on the evolution of the English landscape in his *The Making of the English Landscape*, a pioneering work that had an immediate and lasting influence on environmental and historical conservation, as well as the academic study of local and landscape history.

Hoskins' first appointment at University College was as a lecturer in commerce, a subject that he confessed he found too dull to teach effectively. He found his evenings at Vaughan College, where he taught archaeology and local history, more enjoyable and entertaining. His academic research extended to historical demography, urban history, agrarian history, the evolution of vernacular architecture, landscape history and local history. He was awarded his Doctorate and in 1938, was appointed a reader in English local history at University College.

In 1948, a group of local historians, including Hoskins, formed a Leicestershire Victoria County History Committee to prepare for the publication of further volumes of the Victoria County History (VCH) for Leicestershire by the University of London. Hoskins became the honorary local editor. He planned the contents of the second and third volumes of the VCH (the first volume having been published in 1907), and edited most of the submitted material.

After working at Oxford for some years, Hoskins returned to Leicester and the university in 1965, when he was appointed Hatton professor of English history. He wrote and presented a BBC television series *The Landscape of England* in 1976.

## 67. W. CONRAD SMIGELSKI
## Town Planner

The city of Leicester is changing daily, and much of that change is imperceptible, although local government legislation has increasingly established control of even the most minimal elements, such as the removal of a tree or the installation of a litter bin.

It was local government that was responsible for some of the most dramatic changes in the nature of the city of Leicester, and in particular the city centre and the historic 'old town' area when Conrad Smigelski was the city planning officer.

Smigelski's plans were published in summary form in 1968 under the title *Leicester: Today and Tomorrow*. It has to be noted that 'yesterday' was not a word that the town planners of that time chose to use or recognise.

He is now regarded by many as a visionary planner. He saw the potential for the pedestrianisation of the central area, including Humberstone Gate, Granby Street and Gallowtree Gate, and the use of external escalators and monorails to connect people with their vehicles, parked on the perimeter of the shopping area.

A number of the controversial elements of this scheme, specifically the Central Ring Road, which was to cut through the most historic area of Leicester, was not originated by Smigelski, but inherited by him and his team. The general route of this road had been mapped out as early as the 1930s, although the precise route – the stretch from Granby Street to Welford Road – was later altered.

Concrete has been employed as a building material since the Roman period, but it was in Smigelski's time that the material became the favoured component of architects and builders. To some extent, Smigelski's plans would have appeared less brutal if they had been conceived in familiar and warm red brick. However, those elements of his plan that were completed looked stark and sterile, and, after three decades, are now showing signs of wear, tear and disintegration.

One of Smigelski's major influences had been the open spaces and piazzas of cities in warmer areas of Europe. Translated to Leicester, these areas, rather than fostering the gathering together of communities, become barren because of the English weather.

Today, the public open space is back on the agenda, but it is softened by grass, flower borders and trees – and town planning now respects the architectural heritage of the past.

## 68. JAMES KEMSEY WILKINSON, 1906–1997
### Founder, Wilkinson Retail Stores

Number 151 Charnwood Street, in a cluster of local neighbourhood shops known to many in the area as 'old Charny', was the location of J. K. Wilkinson's first shop. Wilkinson and his fiancée Mary Cooper opened their first shop in 1930. James' brother Donald was already running a hardware store in Birmingham, and the two brothers worked together to acquire stock. Two of Donald's Handsworth stores were later to join the main Wilkinson chain.

In 1932, the Wilkinsons opened their second shop – in Wigston Magna – and the couple were married in 1934 at St Peters, Highfields. Family legend suggests that the wedding took place at 8.00 a.m. so that they were both able to be back at their shop by 11.00 a.m. In 1938, another brother – John – joined the business and in the following year, offices and warehousing space was acquired in the Syston area. Six more stores were opened in 1939.

J. K. served with the Royal Armoured Corp during Second World War, leaving his brother John to manage the company. Three of the shops closed during the war, but reopened in 1948. The growth in popularity of DIY in the post-war decades greatly assisted the chain to expand. In 1958, their largest store to date was opened in Leicester's Charles Street. It traded until the 1990s, when larger premises were secured further along Charles Street at Epic House.

The group operates over 300 stores. J. K. – as he was familiarly referred to within the company – remained closely associated with the business until his death in 1997. Tony Wilkinson, the son of the founder, retired after forty-five years as chairman in 2005 to be replaced by his niece, Karin Swann, and his daughter, Lisa Wilkinson.

## 69. FRANCIS CHARLES ALBERT CAMMAERTS, 1916–2006
### Resistance Hero and Principal, Scraptoft College

His known and recognised services to Leicester lay in his role as principal of the Teacher Training College at Scraptoft, which became a part of De Montfort University. His indirect services to Leicester, and indeed the free world, can be best described by offering an account of his 'alternative' character and role.

He was a pacifist who was to become the head of a spy network that penetrated deep into Nazi-occupied Europe during the Second World War. He went there himself and was

captured, interrogated and tortured by the Gestapo. And then, when hostilities ended, he came to Leicester where no one would know of his past existence.

After teaching briefly in Belfast, he became a teacher at Penge School for Boys. At this time he became a pacifist and refused to wear a uniform when called up for war service in 1939. As a consequence, he lost his job and was instructed to work as a farm labourer in Lincolnshire.

Some years later, he was working for Britain's most secret wartime department. Once, driving in remote country, he was stopped by an SS patrol that searched him. They found nothing and waved him on, not noticing that the car sat low on the road because its boot was full of arms and ammunition.

He later fell into German hands at a road control. He was recognised and sentenced to death. With remarkable courage, his courier, a Polish countess known as Christine Granville, bribed his captors to let him go. She was awarded a George medal.

After the war, Cammaerts created an international system for the exchange of schoolchildren in Western Europe, run from Paris under UNESCO. He later decided to return to teaching, first in Kenya, then at Nairobi University as professor of education, and as headmaster of Rolle College in Exeter. He served from 1952 until 1960 as headmaster of Alleyne's Grammar School, Stevenage, and in 1960 gave evidence for the defence when Penguin Books was prosecuted for publishing *Lady Chatterley's Lover*. In 1966, ready to take on a new challenge, he went to the University of East Africa in Nairobi to set up its education department.

## 70. CEDRIC AUSTEN BARDELL SMITH, 1917–2002
Statistician and Geneticist

Born in Leicester, Cedric Austen Bardell Smith went to Wyggeston Boys' School and University College School, London. He failed his Higher School Certificate but was awarded an exhibition to Trinity College Cambridge.

While a student at Cambridge, Smith became close friends with three other mathematics students at Trinity College – R. L. Brooks, A. H. Stone and W. T. Tutte. Together they tackled a number of problems in the field of mathematics, and went on to invent a fictional imaginary mathematician whom they called Blanche Descartes. Under that name they published their revolutionary work.

During the Second World War, as a Quaker, Smith joined the Friends Relief Service and worked as a porter at Addenbrooke's Hospital in Cambridge. His pacifist views led him to peace studies. He became a member of the Quaker Peace Studies Trust, which established the chair of Peace Studies at the University of Bradford, and he was a founder member of the Conflict Research Society.

In 1946, he was appointed assistant lecturer at the Galton Laboratory at University College London where he remained for the rest of his career, becoming a lecturer, then a reader and finally the Weldon professor of biometrics in 1964.

At the Galton Laboratory he made many significant contributions to genetics, including the test for 'mimic loci'. He contributed to many of the classical topics in statistical genetics, including segregation ratios in family data, kinship, population structure, assortative mating, genetic correlation and estimation of gene frequencies.

Smith was elected a fellow of the Royal Statistical Society in 1945. He was a member of the Genetical Society, the Biometric Society and the International Statistical Institute.

## 71. HAROLD HOPKINS, 1918–1994
## Optical Physicist

Born into a poor family in one of the poorest areas of Leicester, Hopkins secured one of only two local scholarships to Gateway Grammar School where he excelled especially in the arts. The headmaster, however, recognising his gift for mathematics directed him into science.

He went on to read physics and maths at University College, Leicester, graduated in 1939 with a first class honours and then began a PhD in nuclear physics, which was cancelled on the outbreak of war. He then went to work for Taylor & Hobson in Leicester, where he was introduced to optical design.

He was initially refused reserved occupation status at the outbreak of the Second World War and so was called up and trained briefly in blowing up bridges. He appeared to be accomplished at this task and achieved the rank of unpaid lance corporal, winning a prize for his speed at dismantling and reassembling his rifle.

The error of this placement soon became apparent and he was set to work on designing optical systems for the rest of the war, and was able at the same time to work on a thesis for his PhD, which was obtained in 1945.

He began a research fellowship at Imperial College London in 1947, lecturing in optics and in the decades that followed he became one of the foremost authorities in the field of optics.

The secret of his success lay to a great extent in the very advanced mathematics that he brought to the subject. The development of the mathematical description of the behaviour of optical systems was at the centre of his life's work in physics – the application of which produced so many world-famous inventions. He chose to remain at Reading in the post of professor of applied physical optics until his official retirement in 1984, declining the numerous top appointments he was offered. He believed the continuation of his teaching and research work to be more important and far more rewarding personally. Remaining in this role, he received several of the highest academic honours bestowed upon him by scientific institutions across the world.

## 72. MAURICE SELBY ENNALS, 1919–2002
## Manager of Britain's First Mainland Local Radio Station

A meeting in a morgue between the BBC and the then leader of Leicester's Conservative group set the seal on plans for a local radio station in the city and gave Maurice Ennals, a founding father of the concept of local broadcasting, the opportunity to rewrite the motto of the BBC as 'Neighbour shall speak peace unto neighbour'.

Formerly a reporter on the *Melton Times* in Leicestershire, Ennals created Britain's first BBC radio station from scratch at the top of a multistorey office block in Leicester's city centre.

It was the immediate post-war Beveridge Report of 1949 that first proposed local radio as it is defined today. The former BBC war correspondent Frank Gillard and Ennals are widely credited as the founding fathers of the modern format.

It was not until December 1966 that the BBC was granted permission to run a two-year experiment with eight local radio stations in England, and it was on 7 March 1967 that the then postmaster general, Edward Short, announced the names of the first three BBC Local stations, which included Leicester.

However, in the elections of 1967, political control of the Corporation in Leicester changed, and the Conservatives indicated that they would not see through Labour's previous plans to provide funding for an experimental BBC station in the city. The meeting, brokered by Roland Orton, head of the Leicester News Service, which already provided the BBC Home Service in Birmingham with news from Leicester, took place in the BBC Studio on Freeman's Common, the former city morgue.

The *Sun* newspaper reported that electrical dealers in Leicester had posted an increase of 300 per cent in the sales of VHF sets and that there were waiting lists for more expensive models.

Ennals and his small team faced powerful opposition from the local newspapers who feared that local news from the BBC would damage their circulation. He also faced internal challenges from other sectors of the BBC who did not support the idea of local radio.

With remarkable energy and conviction, Ennals contacted and consulted with individuals from every area of the local community, while fending off the public criticism, training his team, and managing the construction of a complete radio station from scratch on the eighth floor of a city centre office block.

It is largely due to Ennal's shrewd and energetic project management that the station opened on time at 12.45 p.m. on 8 November 1967, and two years later, along with the other seven pilot operations, it was deemed a success, leading to extension of the fledging network across the county.

Ennals moved south to launch BBC Radio Solent. He remained in the Hampshire area for the remainder of his life.

*Left*: Francis Charles Albert Cammaerts, 1916–2006. *Middle*: Maurice Selby Ennals, 1919–2002. *Right*: The opening of BBC Radio Leicester on 8 November 1967. Manager Maurice Ennals (*right*) with Rt Hon. Edward Short (*far left*) and Lord Mayor Sir Mark Henig.

## 73. ELIZABETH MARY DRIVER, 1920–2011
**Actress**

Betty Turpin, the longest-serving barmaid at the Rover's Return, was born Betty Driver at the Prebend Nursing Home, No. 11 Prebend Street, on the corner of Brookhouse Street, Leicester.

Yet when she joined the cast of *Coronation Street*, she had already been in show business for more than forty years as an actress, singer and entertainer.

The family moved to Manchester when she was just two years old, but throughout her long life, Betty felt strong ties with the city of her birth.

She had an unhappy childhood. Her parents showed little affection to either Betty or her younger sister Freda. At the age of eight she discovered that she could sing, and her mother immediately began forcing her to enter a string of talent contests. By the time she was twelve, she was touring the country. At fourteen she was given the leading role in the revue *Mr Tower of London*, and was noticed by George Formby, who then cast her in his film *Boots! Boots!*.

However, her scenes as a cabaret singer were cut out at the insistence of Formby's wife, who was also appearing in the film and felt that the young girl was likely to upstage her. Her name was left in the credits and when the film was reissued on DVD, Betty's scenes were restored.

Betty decided to retire from show business in 1969 and ran a pub with her sister near Manchester. She returned to the limelight when agreeing to take on the role of Betty Turpin for the Granada soap opera, appearing in over 2,800 episodes.

She lived with and cared for her sister Freda until Freda's death in December 2008. She was made an MBE in the Millennium Honours List (December, 1999). Betty died in May 2011 after being ill with pneumonia for several months.

## 74. THE RT HON. THE LORD ATTENBOROUGH, CBE, 1923–

Richard Attenborough's first stage appearance was at Leicester's Little Theatre in Dover Street. He studied at Wyggeston Boys' School and then attended RADA.

His first film role was in *In Which We Serve*, released in 1942, playing the uncredited role of a deserting soldier. In real life, he served with the RAF, undergoing pilot training, but was then assigned to the RAF film unit at Pinewood Studios.

He has either acted in or directed nearly eighty films in his long and distinguished career, in which he has gained numerous honours and awards. Away from films, his remarkably active life has involved supporting numerous charitable institutions worldwide, and he has remained close to Leicester, his 'adopted' city.

In 2007, Lord and Lady Attenborough announced that their Picasso ceramics collection would be entrusted to the City of Leicester to commemorate the lives of their daughter, Jane Mary, and their granddaughter, Lucy Elizabeth, who perished together in the Asian Tsunami on 26 December 2004. A permanent exhibition of some forty items from the collection is housed at the art gallery in New Walk.

Lord Attenborough was also the driving force behind Embrace Arts, formerly the Richard Attenborough Centre for Disability and the Arts in Leicester's Lancaster Road, and in 2013 he announced his support for Leicester's campaign to become the UK City of Culture in 2017.

## 75. BILL WOODWARD, 1924–2013
## The Face of Mastermind

By chance, a hairdresser from Leicester became one of the world's most familiar faces by appearing on the lid of the board game Mastermind.

The game was invented by an Israeli postmaster and telecommunications expert, and licensed to Invicta Plastics, based then in Oadby, who launched it in 1971.

Bill served as an RAF mechanic during the war and was a member of the RAF Halton Apprentices Association. He and his son also set up a fund that resulted in the Victoria Park memorial to the men of the US 82nd Airborne Division who were based in Leicester prior to D-Day.

He took part in the photo shoot for the Mastermind box because a male model recruited by an advertising agency friend had failed to show up. The female model was Cecilia Fung, a student at Leicester University. The photograph became one of the world's most iconic and enduring images. Mastermind is still on sale, but is now manufactured under licence by Hasbro in the Far East.

The iconic Mastermind box lid – the original and the models' reunion.

## 76. SIR DAVID ATTENBOROUGH, 1926–

Through his unfailing and seemingly inexhaustible enthusiasm for the natural world, Sir David Attenborough has become the world's most well-known and respected naturalist.

His success is due to his remarkable ability to use modern televisual technology to successfully connect with his audience, together with his total honesty and modesty.

Sir David's childhood was spent in and around College House on the campus of the University of Leicester, where his father was the principal. He attended Wyggeston Boys' School and gained his first degree from Clare College Cambridge.

In 1950, he applied to join the BBC, and by 1969 had become director of programmes for the two main BBC television channels. His name was proposed as a future director general, but before becoming a formal candidate he resigned to concentrate on his true passion of programme-making.

To quote the *Guardian* newspaper, Attenborough's contribution to broadcasting and wildlife film-making has brought him international recognition. He has been called 'the great communicator, the peerless educator' and 'the greatest broadcaster of our time'. His programmes are often cited as an example of what public service broadcasting should be, even by critics of the BBC, and have influenced a generation of wildlife film-makers.

Underlying his lifetime's achievements is a boyish fascination for the animals that populate this planet, a fascination that was encouraged in Leicester by visits to the New Walk Museum.

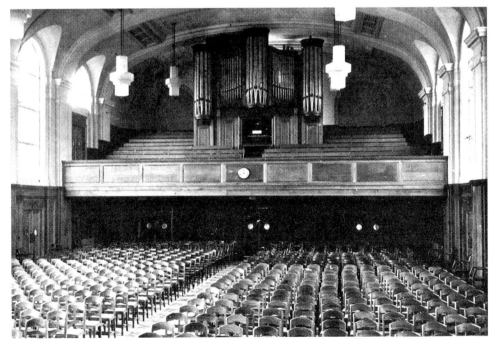

The hall at Wyggeston Boys' School, now the Wyggeston and Queen Elizabeth I College.

## 77. WALTER WILLIAMS AKA BILL MAYNARD, 1928–
**Comedian and Actor**

Bill Maynard was born in Heath End, a village in Surrey, when his father was a serving Army officer in nearby Aldershot. He attended Kibworth Grammar School in Leicestershire, and has lived in Leicestershire for most of his life. The title of his autobiography, *The Yo-Yo Man*, published in 1975, succinctly sums up his life and career.

Having undertaken various screen and stage roles, and appearing in numerous comedy films, including the *Carry On* series, in 1992 Bill took on the role of Claude Greengrass in Yorkshire Television's long-running popular series *Heartbeat*.

In Leicester, a memorable occasion for theatregoers was his last-minute stand-in appearance as the pharaoh in the Haymarket Theatre's 1974 production of *Joseph and his Amazing Technicolour Dreamcoat*, playing alongside his son Maynard Williams in the role of Joseph.

He retired from show business in 2000 following a series of strokes, but returned to radio broadcasting in March 2003 on BBC Radio Leicester, presenting the weekly *Maynard's Bill of Fare*, which continued until February 2008.

## 78. BARON JANNER OF BRAUNSTONE, 1928–
**Politican, Leading Member of the British Jewish Community**

Greville Janner followed in his father's footsteps by representing the Leicester West Parliamentary constituency for twenty-seven years. He was born in Cardiff where his

A promotional image of Bill Maynard to publicise a phone-in programme on BBC Radio Leicester, *c.* 1975.

parents, originally from Lithuania, had settled. Soon after his birth, the family moved to Barry, Glamorgan, where his father opened a furniture shop.

Barnett Janner originally entered politics to represent the Comrades of the Great War party and later the Liberals, but failed to gain a seat. Eventually he joined the Labour Party and won the Leicester West seat in the 1945 general election. He remained as the member for that constituency until his son took over in 1970.

Greville was appointed a life peer in 1997 on his retirement from politics. He is a leading figure in many British Jewish organisations, and is a member of the Magic Circle.

## 79. TREVOR STORER, 1930–2013
### Founder, Pukka Pies Ltd

An iconic British food company, Pukka Pies, was founded by Trevor Storey who set up the business in his kitchen in Leicester in 1963.

He originally worked in his family's bakery, but chose to create his own business when the family concern was sold. Originally, it was called Trevor Storer's Handmade Pie Company, but changed its name in 1964.

The company now sells around 60 million pies every year, made at its factory in Syston. The company has 300 employees, and is now managed by his sons, Tim and Andrew Storer.

## 80. COLIN HENRY WILSON, 1931–
### Writer and Philosopher, Ripperologist

Colin Wilson left school aged sixteen. His father worked in a Leicester shoe factory, and Wilson found employment in a wool warehouse. He attempted to resume his education but joined the Civil Service and was called up for National Service, working as a clerk in the RAF.

Wilson was just twenty-four years old when his first novel, *The Outsider*, was published by Gollancz. It was immediately influential and was to make Wilson's reputation as one of the most controversial intellectuals of his generation.

He became closely associated with the 'angry young men' of that period, but moved on to explore more existential and some very dark aspects of the human condition. His novel *Ritual in the Dark* (1960) led him to a long involvement in 'Ripperology' – a word that Wilson himself coined to describe the endless fascination of writers and researchers with the Whitechapel Murders of 1888.

Wilson's prolific literary output continued until 2009 and he suffered a stroke in 2012.

## 81. JOAN MAUREEN 'BIDDY' BAXTER, 1933–
### Creator of BBC Television's Blue Peter

Educated at Wyggeston Girls' School and St Mary's College, University of Durham, Biddy Baxter's father was a teacher who became the director of a sportswear company. Her mother was a professional pianist.

She devised *Blue Peter* as a programme that would take children seriously, encouraging them to participate and interact with the presenters by sending in ideas, pictures, letters and

stories. She also launched the programme's now famous annual appeals. The programme was launched in 1965, and she remained the editor until 1988.

In 1981, she was awarded an MBE in recognition of her services to children's television. She is also a fellow of the Royal Television Society and has an honorary doctorate from her old university.

In 2009, Baxter published a selection of children's letters received by the *Blue Peter* team, including citations from some who found the inspiration to learn and to achieve through watching the programme as children.

### 82. JOE ORTON, 1933–1967
## Playwright

John Kingsley Orton's career was short but dramatic, controversial and prolific. In a period of three years from 1964 to 1967 he shocked, outraged, and amused his audiences with his black comedies.

He was born at the Causeway Lane Maternity Hospital in Leicester. His father was a gardener for the Borough Council and his mother worked in a shoe factory. From 1966, the family lived on Leicester's Saffron Lane estate.

Orton went to Marriot Road Primary School, but failed the eleven-plus due to illness, and eventually became a junior clerk working for £3 per week. He became interested in theatre as a teenager, joining various groups, including the prestigious Leicester Dramatic Society. After a period of self-improvement, when he took elocution lessons and bodybuilding courses, he was accepted for the Royal Academy of Dramatic Art (RADA) in 1950.

Orton's short but intense career ended on 9 August 1967 when he was murdered by his lover Kenneth Halliwell at his home in Islington. Halliwell then committed suicide.

Orton was cremated at Golders Green Crematorium. His controversial legacy lives on in Leicester. The pedestrian concourse outside the main entrance to the Curve Theatre is named Orton Square.

### 83. ARNOLD GEORGE DORSEY AKA ENGELBERT HUMPERDINCK, 1936
## Popular Singer

Arnold Dorsey was born in India, as one of ten children of Mervyn and Olive Dorsey. The family moved to Leicester in 1947, and by the 1950s Dorsey was playing saxophone in local clubs. He later adopted the stage name 'Gerry Dorsey' after performing a particularly successful musical impression of Jerry Lewis.

Dorsey struggled to gain success as a singer for many years until his former room-mate Gordon Mills, by then a successful manager of performers such as Tom Jones, suggested he changed his name to the more noticeable Engelbert Humperdinck. The change, coupled with the particularly fine ballad 'Release Me' gave him the success he had been seeking. The record, released in 1967, was in the Top 50 charts for fifty-six weeks. At the height of its popularity, it sold 85,000 copies every day.

Engelbert has enjoyed a long career in popular music. As well as a string of successful singles, he was an established cabaret stage artist, particularly in Las Vegas and other world-renowned

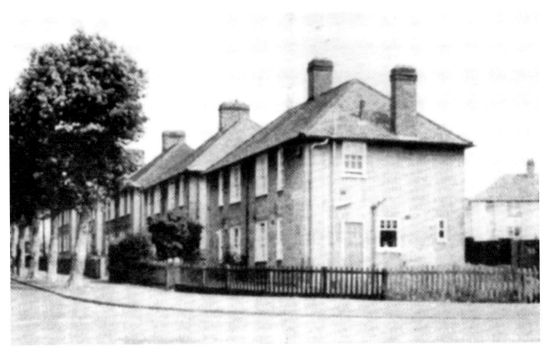

Joe Orton's former home in Fayrhurst Road, Leicester, where he lived for seventeen years.

Joe outside his flat in Noel Street, London, on 22 May 1964. (© *Leicester Mercury*)

Engelbert in his heyday. A 1975 promotional image.

venues. In 2009 he was given the Honorary Freedom of Leicester by Leicester City Council, and in 2012, at the age of seventy-six, he represented the UK in the Eurovision Song Contest. For some years he has lived in the USA but has always maintained a home in Leicester.

## 84. STEPHEN FREARS, 1941–
### Film Director

A film director of international renown, Stephen Frears, has also been immortalised in the line 'Mr Frears had sticky out ears' from the song 'Lily the Pink', recorded by The Scaffold in 1968. Frears worked with the group early in his career.

He was born in Leicester. His father was a general practitioner and accountant, and his mother was a social worker. He studied law at Cambridge but then worked as an assistant director on films including *If* and *Morgan!*. Most of his early career was in television, producing series for the BBC such as *Play for Today* and Alan Bennett plays for ITV.

In the mid-1980s, Frears came to international attention as an important director of British and American films. He became regarded as the director who told stories about good and bad people and others in their world, and of the conditions they face in a world that they must adapt to.

His production of *My Beautiful Laundrette* gave him popular and critical recognition. It received a nomination for an Academy Award and two nominations for BAFTA Awards. Frears also directed the successful British film *Prick Up Your Ears*, about Leicester playwright Joe Orton, and made his Hollywood debut with *Dangerous Liaisons*. His film *The Queen* depicted the death of Princess Diana. It achieved immense critical acclaim, box office success and awards. Frears received his second Academy Award nomination for his direction of it.

Frears holds the David Lean chair in fiction direction from the National Film and Television School where he often teaches.

## 85. GRAHAM CHAPMAN, 1941–89
### Actor and Comedian (Monty Python)

Born at the Stoneygate Nursing Home in Leicester and educated at Melton Mowbray Grammar School, Graham Chapman studied medicine at Emmanuel College, Cambridge, where he joined Footlights, and went on to work and perform with the young comedy writer set of that era, including Bill Oddie and Tim Brooke-Taylor.

As a boy, he was an avid listener to the pioneer radio comedy shows such as *The Goons* and *It's That Man Again* (*ITMA*). By the 1960s, he was writing his own radio scripts with John Cleese for BBC radio shows fronted by Marty Feldman and David Frost.

In 1969, he and Cleese joined Michael Palin, Terry Jones, Eric Idle and Terry Gilliam to create *Monty Python's Flying Circus*, arguably the most significant and influential comedy programme of all time, which in turn inspired a range of other inventive comedy acts and creations, as well as mainstream comedy films.

Chapman moved to Los Angeles for some years but returned to the UK. He was a vocal supporter of gay rights, and he suffered from a lifelong dependency on alcohol. He died in 1989 of pneumonia brought about by throat cancer.

## 86. JONATHAN DOUGLAS 'JON' LORD, 1941–2012
## Musician and Composer

Jon Lord was one of the few musicians of the twentieth century to move successfully and with integrity between the genres of 'classical' and 'rock' music.

He was born in Leicester, had piano lessons from the age of five and attended Wyggeston Boys' School. He worked as a solicitor's clerk for two years before moving to London with the intention of becoming an actor.

His desire to perform led him into jazz, and, in 1967, the formation of Deep Purple, which was to explore the fusion of jazz and rock idioms, influenced strongly by Lord's keyboard skills. His *Concerto For Group and Orchestra*, first performed at the Royal Albert Hall in 1969, was the first major work, which attempted a serious fusion of classical and rock styles. The critical success of this composition and the willingness of the musical establishment to respect Lord's material led to him being able to work across both genres, from Whitesnake to Sir Malcolm Arnold.

In 1997, he created his most personal work, 'Pictured Within', which was influenced strongly by Lord's deep grief at the death of his mother Miriam in 1995.

## 87. CHRISTOPHER BRUCE, 1945–
## English Dancer and Choreographer

Christopher Bruce was born in Leicester and grew up in Scarborough. He began dancing as a therapy to strengthen his legs after catching polio as a child.

After studying at the Rambert School, he joined Ballet Rambert in 1963 to become, in a comparatively short time, their leading male dancer. In 1977, he was appointed associate director of the company and associate choreographer from 1979 to '87, where he created over twenty works for the company. From 1986 to '91 he was associate choreographer for London Festival Ballet and resident choreographer for Houston Ballet in 1989.

He integrates classical ballet and modern dance, often set against popular music by artists including Bob Dylan, and The Rolling Stones. He was awarded the CBE in 1998 and gained an honorary doctorate in arts from De Montfort University in 2000.

## 88. SUSAN LILLIAN 'SUE' TOWNSEND, 1946–
## Novelist, Playwright, Screenwriter and Columnist

The daughter of a Leicester postman, Sue Townsend attended Glen Hills Primary School, South Wigston High School and Mary Linwood Comprehensive School. She left school at the age of fifteen and undertook a number of jobs in local factories and shops. By the age of twenty-two, she was married with three children.

It was not until Sue was in her thirties that she began writing by attending a group at Leicester's Phoenix Theatre, and by the time she wrote the first Adrian Mole novel she had moved to the Saffron Lane estate, living close to playwright Joe Orton's former home.

Adrian Mole, for whom Sue drew upon many close experiences including her own schooldays and her son's childhood, brought her international fame as an author. She has

also written several plays and two non-fiction works, including *Why Britain Needs Its Welfare State*, which consisted of themes she also used in a series of superb commentaries on social issues for the *Observer* newspaper.

Sue has lived with diabetes for some years and is now registered blind, an experience she has used in her later writing. She was awarded the Honorary Freedom of Leicester in 2009.

## 89. ROSEMARY CONLEY, 1946–
## Fitness Expert and Businesswoman

Famous for her *Hip and Thigh Diet*, published in 1988, which sold over 2 million copies, Rosemary Conley was the first woman to be granted the Freedom of the City of Leicester. She served as deputy lieutenant of Leicestershire in 1999, and was awarded the CBE in 2004.

Rosemary attended Bushloe High School in Wigston and secretarial college, before studying for a qualification in exercise to music. In 1972, she began running evening classes for women wishing to lose weight, which developed into a chain of clubs that she later sold to IPC.

Through her franchising company and a range of fitness books, Rosemary became a household name. Locally, she has devoted her time to supporting the promotion of Leicester and Leicestershire as centres for business and commerce, acting as an ambassador for the area.

## 90. SIR ALEC JEFFREYS, 1950–
## Geneticist and Pioneer of DNA Fingerprinting and Profiling

Born in Oxford and educated in Luton and Merton College, Oxford, Alec Jeffreys' association with Leicester began in 1977 when he was appointed to an academic post at Leicester University.

On Monday 10 September 1984 at 9.05 a.m., Jeffreys saw the potential of DNA fingerprinting, having noticed similarities and differences in DNA samples taken from different members of a colleague's family.

The first use of DNA fingerprinting in a murder case was in the apprehending of Colin Pitchfork, who murdered two schoolgirls (in 1983 and 1986) in the Leicestershire village of Narborough. He was caught after the bakery staff where he worked overheard him boasting that he had succeeded in avoiding giving a DNA sample by paying a friend to take his place.

Sir Alec is now Professor of Genetics at Leicester. The science and techniques he established are now used worldwide. He became a Freeman of the City of Leicester in 1992 and was knighted for his services to science and technology in 1994.

## 91. JOHN RICHARD DEACON, 1951–
## Bass Guitarist, Queen

John Deacon was educated at Linden Junior School in Leicester, Gartree High School and Oadby Beauchamp School. At the age of nineteen, he joined Queen and wrote five of the band's bestselling singles. He was the last to join the group, and the youngest. It is said that he was chosen not only for his talent, but also because of his quiet demeanour (which did not detract from Freddy Mercury on stage), and his electrical skills.

He formed his first band in Leicester, The Opposition in 1965 at the age of fourteen. He played rhythm guitar in the band, but had to borrow from the other band members to raise enough money to buy an instrument. He later moved to being the group's bassist. He played his last gig with the band, by then known as The Art in 1969, before moving to London to study at Chelsea College.

He retired from the music industry in 1997 and now lives in a relatively reclusive manner with his family in south-west London.

## 92. DAVE BARTRAM, 1952–
## Popular Singer, Showaddywaddy

Although a solo performer in his own right, Dave Bartram will be forever associated with Showaddywaddy.

The band was formed in 1973 when two groups, Choise and The Golden Hammers, who both played at the Fosse Way pub in Leicester, decided to join together and become an eight-piece band with two sets of drummers, bassists and soloists. That February they won £1,000 in a talent contest at Bailey's Nightclub in the Haymarket Centre, Leicester, and just months later, on 1 September 1973, they undertook their first professional appearance at the Dreamland Ballroom in Margate.

Their first single 'Hey Rock and Roll' was written by the group and reached No. 2 in the UK Singles Chart in 1974. The group has had 10 Top 10 singles, but just 1 No. 1 ('Under the Moon of Love' in 1976), and has spent 209 weeks in the UK Singles Chart.

Bartram left Showaddywaddy in December 2011 after thirty-eight years fronting the band. His last appearance with them was at the Kings Hall Theatre in Ilkley, West Yorkshire, and their last Leicester appearance together was at the Summer Sundae festival in August 2011. He continues to act as their manager, a role he has held since 1986.

Showaddywaddy still tour, with around 100 gigs every year. In 2013, they undertook a five-month fortieth anniversary tour.

## 93. WILLIE THORNE, 1954–
## Snooker Player and Commentator

Willie Thorne became the national under-16 Snooker Champion in 1970. Although only ever winning one ranking tournament (the Classic in 1985), Thorne is respected for his skilled break building play, and is seen by some as the missing link between the 'percentage play' style of the older snooker generation and the 'potting play' of today's young players.

For some years he struggled with a serious gambling problem, losing considerable sums of money, but throughout his career he was one of the several most recognisable personalities in top-rank snooker, his bald head immediately recognisable in the television lighting of snooker tournaments.

He is sometimes referred to as 'Mr Maximum' because he claims to have hit nearly 200 147-breaks in practice, though only one in a tournament.

For many years, Thorne ran a snooker club in Leicester where the young Mark Selby often trained. He still lives in Leicestershire.

## 94. GARY WINSTON LINEKER, 1960–
## Footballer, Sports Presenter

In his career as a world-renowned footballer, Lineker never committed a foul and was never presented with a yellow or red card during his career.

He attended Caldecote Road School and Leicester Boys' Grammar on Downing Drive in the city. As a lad, Lineker excelled in cricket as well as football. From the age of eleven, he captained the Leicestershire School cricket team and believed he had more chance of succeeding at cricket than football. His father, grandfather and great-grandfather were greengrocers, and the family still trades in Leicester's market.

When he left school with four basic O-levels, one teacher commented that he 'concentrates too much on football' and that he would 'never make a living at that'. Shortly afterwards he joined the youth academy at Leicester City.

His career is legendary. Lineker retired from international football with eighty caps and forty-eighty goals. He transferred, quite effortlessly, to a new career as a television sports commentator, a role that has also offered him work as a newspaper columnist and television presenter in European and American markets.

His popularity has allowed him, since 1995, to feature in a light-hearted series of commercials for the local company, Walkers crisps. Walkers temporarily named their salt and vinegar crisps after Lineker in the late 1990s as 'Salt-n-Lineker'.

Leicester City Football Club's Filbert Street Ground. Gary Lineker played 194 matches for Leicester City and scored 95 goals.

## 95. GOK WAN, 1974–
### Television and Celebrity Fashion Consultant

Gok Wan was born in Leicester to a Chinese father, John Tung Shing Wan, who was born in Hong Kong, and to an English mother named Myra. He attended Leicester College, studying drama. He recounts how he suffered by being not only an immigrant, but also gay and over-weight – at that time, such personal 'attributes' were not as acceptable as they are today.

His incredibly powerful personality and charm empowered him to move into the world of fashion, where he has worked with many international celebrities including Damian Lewis, Erasure, Vanessa-Mae, Lauren Laverne, Wet Wet Wet, and Johnny Vaughan.

He works for magazines as a fashion consultant, and his material has been published internationally in several magazines. In 2006, Wan was approached by Channel 4 and invited to present his own fashion show, *How to Look Good Naked*. He has been able to invent new ideas and concepts, which have kept him at the cusp of celebrity to the present day. Gok's parents run a chip shop in Leicestershire.

## 96. PARMINDER KAUR NAGRA, 1975–
### Actress

One of the first members of the Leicester Asian community to achieve international stardom, Parminder Kaur Nagra was born in Leicester, and is the eldest child of Sukha and Nashuter Nagra – Sikh factory workers who emigrated from the Punjab region of India in the 1960s.

The Leicester Haymarket Theatre Haymarket Theatre before its opening in October 1973. The theatre closed in 2007.

Parminder went to Northfield House Primary School and Soar Valley College, where she played viola in the youth orchestra and also appeared in her first theatrical productions.

Soon after her A levels and leaving school, while working front-of-house at the Haymarket Theatre, her former drama instructor invited her to join Hathi Productions, the Leicester-based Asian Youth Theatre Group. She agreed and was cast as a chorus member in the 1994 musical *Nimai*, presented at the Haymarket. One week into rehearsals she replaced the lead actress.

Her international television and film career has included the role of Jess in *Bend It Like Beckham* (2002), Dr Neela Rasgotra in the American television medical series *ER*, and Dr Lucy Banerjee in Fox Broadcasting Company's *Alcatraz*.

## 97. RESHAM SINGH SANDHU
### First Sikh to be Appointed High Sheriff of Leicestershire (2011)

Resham Singh Sandhu was born in Punjab. He moved to Leicester in his youth. Later, he became the chairman of Leicester's Council of Faiths, and the chair of the County Faith Forum. In 2006, he was commissioned as a deputy lieutenant of Leicestershire.

He was awarded the MBE in 2002 and became the first Sikh in the UK to hold the office of High Sheriff.

In accepting the appointment, Resham commented that 'my family in Punjab always worked with communities and to help other people. When I came over here I wanted to do the same. I didn't do it because I wanted to be recognised for it – I never expected that'.

## 98. SIR PETER ALFRED SOULSBY, 1948–
### First Elected Mayor of Leicester

Sir Peter was the MP for Leicester South from 2005 until he resigned to stand as a candidate for the post of elected mayor of the city in 2011.

He was born in Bishop Auckland in County Durham. His association with Leicester began when he became an undergraduate at the City of Leicester College of Education in Scraptoft. He graduated from Scraptoft with a BEd degree and commenced his career teaching at Crown Hills Secondary Modern School, and in special needs schools within the city.

He was first elected to Leicester City Council in 1974 and continued as a Labour councillor until 2003. Despite his own opposition to the Iraq War and his participation in rallies and marches, his defeat was said to have reflected the widespread local opposition to the war.

He contested the Harborough parliamentary seat in 1979 and stood in 1984 as a candidate in the European Parliament for the Leicester European Parliamentary constituency. In 2004 he was the Labour Party's candidate in the Leicester South by-election. He lost to Parmjit Singh Gill of the Liberal Democrats in a by-election that was dominated by the Iraq War and the newly-formed left-wing party Respect, which took 12.7 per cent of vote. In the 2005 general election, he regained the seat.

He was elected as mayor of Leicester on 5 May 2011, with a majority of 37,260 votes. Since July 1998, he has served on the board of British Waterways as vice chairman. He is a senior Unitarian, serving on the Executive Committee of the General Assembly of Unitarian and Free Christian Churches. He acts as its convenor and as the 'Keeper of the Books' at the

Sir Peter Soulsby, Leicester's first elected mayor.

Dilwar Hussain.

Geoff Rowe, founder of Leicester Comedy Festival.

Great Meeting in Leicester. He was knighted in 1999 for his services to local government. It is said that he has traversed much of the British canal network in his own narrow boat.

## 99. DILWAR HUSSAIN
### Leading Islamist

Hussain is the head of the Policy Research Centre, based at the Islamic Foundation, Leicestershire. He has taught Islamic concepts throughout the word at undergraduate and postgraduate levels, as well as organising courses for civil servants on Islamic issues.

He was involved in the Contextualising Islam in Britain project (2009) at Cambridge University, and is a fellow of the Royal Foundation of St Katharine's Contextual Theology Centre, and a fellow of the Faiths and Civil Society Unit at Goldsmith College.

Hussain's concepts and primary research interests are social policy, Muslim identity and Islam in the modern world. He believes that Islam should develop further to become a 'normal and integral' part of British life. He is a senior adviser to the Institute for Strategic Dialogue and is an associate of the think tank, Demos. He served on the Archbishop of Canterbury's Commission on Urban Life and Faith (2005–06) and was co-chair of Alif-Aleph UK (2005), a pioneering network that brings together British Jews and Muslims.

He is married with four children and lives in Leicester. He has expressed great concern regarding violence initiated by Islamic fundamentalism. His view is that it is not only a problem for the Muslim community and has stated that: 'we need to stand together to tackle, alienate and isolate those extreme voices'.

## 100. GEOFF ROWE
### Founder and Chief Executive, Dave's Comedy Festival

Bored, and finding little to do in his village, Geoff Rowe promoted his first concert at the age of thirteen in his local village hall. It was successful and gave him the stimulus to arrange further events throughout his teenage years.

He worked briefly in the music industry in London before moving to Leicester to start an Arts Administration course at the Scraptoft campus of De Montfort University. One of his student placements was the opportunity to be involved in the public celebrations for the opening of the channel tunnel in Folkestone.

As part of his final year studies, Geoff helped launch the Leicester Comedy Festival in 1994. That first week-long festival involved 40 events in 23 venues throughout Leicestershire and attracted over 5,000 visitors. The acts included Matt Lucas and Harry Hil.

In 2009, Geoff was named as one of Midlands *Business Insider* magazine's '42 Under 42', a programme where the achievement of entrepreneurs in the Midlands under the age of forty-two are recognised. He was awarded the British Empire Medal for his services to comedy in the Queen's Jubilee Year, and was given an honorary Doctorate of Arts in 2012 from De Montfort University.

Research has shown that the Leicester Comedy Festival boosts the local economy by about £2 million every year. In 2013, the festival involved no fewer than 530 events in more than fifty venues in Leicester and Leicestershire. Leicester is, it seems, laughing all the way to the bank.